BECOMING *His* MASTERPIECE

Fifty-Two Devotional and
Abstract Art Pairings to Encourage You
on Your Lifelong Journey

Sharon Collins

Deep*River*
B O O K S

Becoming His Masterpiece
Copyright © 2020 by Sharon Collins
Published by Deep River Books
Sisters, Oregon
www.deepriverbooks.com

All rights reserved.

ISBN – 13: 9781632695376

Library of Congress: 2020943227

Printed in the USA

Cover and interior design by Robin Black, Inspirio Design
Cover painting photographer: Martin Holmes, Martin Holmes Photography, Houston, TX

Portrait photographer: Julia McLaurin, Sytenka Studios, Houston, Texas

Painting photographer: Rick Wells, Rick Wells Photography, Houston, TX

The following paintings are used by permission of the owners:
Homeward Bound: Maureena McDonald
Holy Wind: Denise Phelps
Spirit Fruit: Becky Morris
Deeply Rooted: Dolores Jane Holick
Circle Dance: Dolores Jane Holick
Holy: Angela and Dath Collins
Firmament: Dolores Jane Holick
Desert Spring: Cara and Casey Garlow
Wardrobe: Karen Welton
Our Light: Julie Enis
Jar of Clay: Judy Prisk
Small Refreshments: Dolores Jane Holick
Abundance: Glen D. Hall
City on a Hill: Dolores Jane Holick

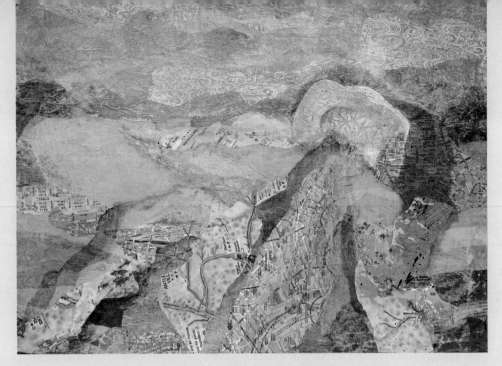

DEDICATION

*I*n loving memory of my twin sister, Karen, who went to be with Jesus on April 24, 2016. I suspect she somehow convinced God to let me borrow a smidgeon of her prodigious creative gifts thus enabling this book. I am eternally grateful for the loan.

Ever since I started to paint, I wanted to create a tribute to Karen, but for a long time the inspiration didn't come. It finally arrived in early 2020 after a six-week period during which three friends (Jo, Trish, and George) went to their eternal home. It was at that point that the Holy Spirit led me to paint *Homeward Bound.* It became my tribute to these dear friends as well as to Karen. All of them are now together in their new heavenly home experiencing the wonder of eternity with their loving Savior.

Homeward Bound resides in the home of George's widow, Maureena. I think Karen is pleased!

HOMEWARD BOUND PAINTING

"But our citizenship is in heaven. And we eagerly await a Savior from there, the Lord Jesus Christ, who, by the power that enables him to bring everything under his control, will transform our lowly bodies so that they will be like his glorious body." Philippians 3:20-21

ENDORSEMENTS

Sharon's art pieces communicate the principles of Scripture from a fresh, inviting, and delightfully whimsical perspective. Her first-person writing style makes readers feel as though they have taken a seat at her breakfast table, listening as she shares wisdom gained from her personal journey with God and her knowledge of his Word. Her art and her words draw us in. Sharon stirs our spiritual hearts with her stories and reveals the deep things of God with her art.

MINDY FERGUSON, Author and Bible Teacher, Fruitful Word Ministries, Inc.

Sharon reminds us that we are today both divinely inspired masterpieces and emerging masterpieces. Her creative works open the mind and heart to receive and then recall God's truths, interpreted through her own journey. Both "sides" of our minds are activated and blessed through her personal, approachable, and transparent gifts of reflection and creativity.

MICHAEL J MONTEL, PhD, President and CEO, Living Water International

When we think of historical masterpieces we may consider Leonardo da Vinci's Mona Lisa or Rembrandt's *The Return of the Prodigal Son*. However, in this collection of devotionals, Sharon uses her words to paint an exquisite portrait of how we can embrace being God's masterpieces. Living with holy expectations, we have the transformational privilege to be the frames that hold and carry Jesus into the world. As you take time to gaze on the words of each page, may you see with clarity the depth of God's love for you. Thank you, Sharon, for the beautiful reminders that God is not done with us yet.

THE REV DR TREY H LITTLE, Former Senior Pastor, Grace Presbyterian Church, Houston, TX

Cultivating the practice of being with God is both gift and discipline. For some, it is a journey of delight and for others it is one of faithful practice. Sharon has animated both of these attitudes in her writing and with her art. She's given her readers a way of being with God in imaginative ways, inviting all of us to deepen this spiritual relationship that has breathed life into her journey and her art. This is a beautiful reflection of God at work through Sharon's reflections. Read, reflect, and find delight in these words and through her art.

KAREN E PARCHMAN, PhD, Director, Talent and Leadership for Vision Fund, a ministry of World Vision, International

Christians have classically compared the Bible to a pair of glasses: its message brings authoritative clarity to human experience and God's work in the world. Sharon Collins' devotional thoughts, paired with her paintings, work similarly in opening vistas for the individual's life before God. Her inspiring reflections on biblical truth and her insightful paintings are two portals for gaining perspective on what she calls "the journey of a lifetime."

ANDREW DEARMAN, Professor of Old Testament, Fuller Theological Seminary

Sharon's creativity is both artistically appealing and instructive. Her work subtly asks us to take a fresh look at Biblical principles. Each devotional is a story within the larger narrative of God's desire for a relationship with us. These insights demand reflection and thereby renew fresh appreciation for the beauty that surrounds us. The psalmist said, "Be still and know that I am God." In the vernacular, that means loosen your tight-fisted grip on life and recognize the providence of God. Thanks Sharon, for helping me do just that.

THE REV DR DAVID MCKECHNIE, Interim Pastor, Carmel Presbyterian, Charlotte, NC,

Pastor Emeritus, Grace Presbyterian Church, Houston, TX

ACKNOWLEDGMENTS

Our almighty God is the true author and artist of this book. Without his gentle guidance through the power of his Holy Spirit, I would not be able to write or paint anything worthwhile. For the life of me, I can't understand why he chose me for this task, but I am deeply grateful and humbled. Through this process, God has taught me (a notoriously slow learner of all things spiritual) profound lessons that have enriched my life beyond measure. All praise and honor belong to him.

My husband, Ron, has been my most faithful supporter from day one. Since I first picked up my paintbrush in the fall of 2017, he has never complained about the ridiculously high price of painting supplies or the loss of a bedroom to my creative paraphernalia. He was the first to say, "You should do it" when I felt called to start a website. Long before I could see it, God gave him a vision for this book. God blessed me richly and in so many ways when he brought Ron into my life and I am forever grateful.

There are some women in my life who have seen in me what I could not see in myself. Shirley Beyer, after seeing me doodle on a cocktail napkin, told me, "You should take art lessons." Linda Bradshaw, after reading a mini-devotional I wrote for our Bible study group, told me, "You should write a book of devotionals." God used these women to start me on this unexpected journey. I am so grateful for their God-inspired nudges.

I have been blessed with many encouragers along the way. Denise Phelps (Director, Caring Ministries, Grace Presbyterian Church, Houston, TX) and Mindy Ferguson (Author, Speaker, President, and Founder of Fruitful Word Ministries, Inc.) have consistently provided wisdom and encouragement along my journey. My best gal pals (you know who you are!) have loved me despite my quirks and faults. We have walked together through many of life's ups and downs. Their love is part of the bedrock on which I can stand.

I am profoundly grateful for Andy Carmichael and the editorial team at Deep River Books who saw potential in my proposal submission and were willing to take a chance on a complete novice. As a new author, I was a bit apprehensive about the editorial process. That was silly of me really, because God had already chosen Carolyn Currey to edit *Becoming His Masterpiece*. Her gentle and wise editorial counsel resulted in improvements that I could not have conceived.

Throughout this journey God's constant provision has been extraordinary. It is what he is all about—for each of us. To him be all the glory!

TABLE OF CONTENTS

INTRODUCTION

I wrote the devotional on the next page, *Unexpected Journey*, a few weeks after I did an uncharacteristic thing. When God called me to create a website to post devotionals and paintings, I immediately obeyed. The website was launched on May 1, 2018. Over the course of the next eighteen months, through the power of the Holy Spirit, I wrote and painted over fifty-two devotional/art pairings.

Early on, my husband, Ron, had a sense of where God was taking my efforts (long before I had a clue!). He would frequently tell me, "You should do a book." I always rolled my eyes and ignored him. At milestone fifty-two, Ron's comments started to germinate in my soul (along with the stirrings of the Holy Spirit), and I began to investigate the possibilities.

Against enormous odds, *Becoming His Masterpiece* started to become a reality. It is proof, really, of the rock-solid truth found in Ephesians 3:20 (NLT), "Now all glory to God, who is able, through his mighty power at work within us, to accomplish infinitely more than we might ask or think." Through his mighty power and mysterious providence, God chose me (a grandmother with zero aspirations to write or paint) to trust him and cling to his promises while traveling on an improbable journey.

At the end of this first devotional, I list some of God's promises that enabled me to take that leap of faith. Just so you know, I'm still clinging to those promises!

UNEXPECTED JOURNEY

—WRITTEN MAY 1, 2018

*L*et's all just agree that God has a sense of humor. He has to! Otherwise, he wouldn't ask a sixty-seven-year-old grandmother with five months of painting experience to write Christian devotionals inspired at least in part by her artwork.

In Isaiah 55:8 God says, "For my thoughts are not your thoughts, neither are my ways your ways." As I thought about this, it occurred to me that God has a habit of asking the unqualified or unlikely to do something that seems ridiculous from the world's point of view. Some examples:

- He told a "slow of speech" fugitive from justice (Moses) to lead his people out of Egypt.
- He told an adolescent, shepherd boy (David) that he would make him King of Israel.
- He asked an unmarried, teenage girl (Mary) to bear his Son.
- He called a persecutor of Christians (Paul) to become his agent in spreading the gospel of Jesus Christ to the Gentiles.

Clearly his ways are not our ways. Now, what he called me to do is hardly of the magnitude of these Biblical examples, but let me just share my lack of qualifications:

- I had my first art class ever in November of 2017.
- No one would ever use the words "biblical scholar" in the same sentence with my name.
- While I have been a Christian a long time, I'm an extremely slow learner, especially when it comes to applying the truth of God to my life on a consistent basis.
- My devotional writing has been limited to a few mini devotionals for my Bible study small groups.

But God in his gentle way has made sure that certain Bible verses were absolutely "in my face" as I contemplated this journey with him:

- "I can do all things because of Christ who strengthens me" (Philippians 4:13, MEV).
- "My grace is sufficient for you, for my power is made perfect in weakness" (2 Corinthians 12:9).
- "And God is able to bless you abundantly, so that in all things at all times, having all that you need, you will abound in every good work" (2 Corinthians 9:8).

I am clinging to these promises as I start this journey. By the way, these promises apply to you too, so grab hold of them with me.

May everything you read and see in this book be for his glory alone!

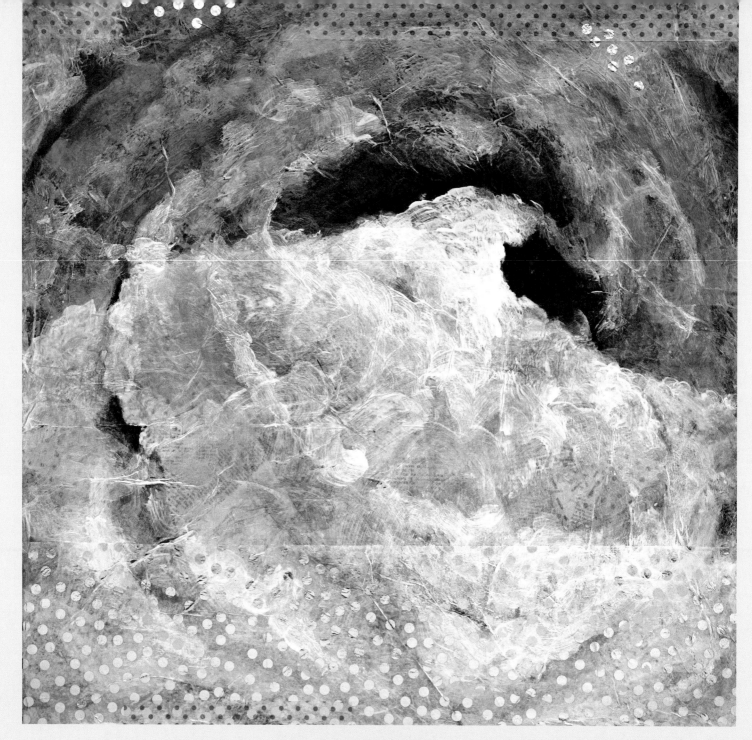

LIGHT ETERNAL

"He who was seated on the throne said, 'I am making everything new!'" Revelation 21:5

NEW

Happy New Year! This phrase has been on our lips for the past few days. We will continue to say it for a few more and then it will slowly fade away. It seems to me a little sad that the celebration of the "new" is so short-lived. I happen to like new. I like new shoes, new clothes, a new coffee maker (just got one), and new paintings! The problem with the new things is that sooner or later, they become old and worn. Then I find myself not liking them so much. Now, that is not true in every case. I had an old bathrobe I loved and wore way past its prime. I knew no new robe was going to be as comfortable. But eventually it became as transient as all the other new things. It was so worn; I couldn't even donate it. It had to go in the trash. It was a sad day.

Our God is all about the new. But God's "new" is completely different than my new coffee maker or new robe! God's "new" has an eternal quality. His "new" doesn't wear out or have a limited lifetime. Lamentations 3:22-23 tells us his love and compassion for us are new every morning. He has new expressions of his faithfulness available every day. He knows we need new reminders of the eternity of his love as we tend to be forgetful people when it comes to the things of God. Isaiah 42:9-10 says, "See, the former things have taken place, and new things I declare; before they spring into being I announce them to you."

God's love manifests itself in the new. In Isaiah 43:19 he says, "See, I am doing a new thing! Now it springs up; do you not perceive it? I am making a way in the wilderness and streams in the wasteland." His "new thing" is his most eternal and enduring expression of his love—his new covenant with us in Christ Jesus. In Christ, God provided a new and eternal way for us to know and love him more intimately, new opportunities to experience his love and share it with others, new ways to experience his grace, joy, and peace.

He offers us a new life that transcends the decay and transient nature of this world. 2 Corinthians 5:17 tells us, "Therefore, if anyone is in Christ, the new creation has come: The old has gone, the new is here!" Eventually we will all leave this earthly home, relocating to an eternal home that waits for us. God's Word assures us: "For we know that if the earthly tent we live in is destroyed, we have a building from God, an eternal house in heaven, not built by human hands" (2 Corinthians 5:1).

The book of Revelation reveals even more about God's plans for newness. In Chapter 21 we learn, "He who was seated on the throne said, 'I am making everything new!'" and that he will create a new heaven and a new earth and this old and broken world will pass away. In this painting, *Light Eternal*, I've tried to capture the new life he continuously pours into his creation as well as the eternal nature of that newness. Frankly, that is something that is impossible for me to capture in a painting or even in my brain!

It seems that we should celebrate God's "new" every day of our lives. Our new life in Christ, the new glimpses of his compassion, love, and grace he shows us each day, our new home in heaven and ultimately, his new earth and heaven are all cause for celebration. Why not make each day of this new year an opportunity to celebrate all the ways God has blessed us with his provision of eternal newness? May we all seek, recognize, and celebrate his new provisions all year long!

BECOMING HIS MASTERPIECE

When God called me to write devotionals and paint, he had a purpose. He knew I needed lessons on how to become his masterpiece and he wanted me to pass on my learning to others. I didn't immediately realize his purpose, but our patient God slowly began to reveal himself and his plans to me over time.

He is teaching me that becoming his masterpiece is a lifetime journey that transforms us ever so slowly (at least for me) into his design. Ephesians 2:10 (NLT) tells us, "For we are God's masterpiece. He has created us anew in Christ Jesus, so we can do the good things he planned for us long ago."

God desires that our lives fulfill his purpose for all of us: to glorify him. Within this common purpose, God crafts customized plans for each believer. In his providence, God is able to use all of our gifts, screw-ups, talents, and quirks for his glory. We are reassured of this in Ephesians 1:11-12, "In him we were also chosen, having been predestined according to the plan of him who works out everything in conformity with the purpose of his will, in order that we . . . might be for the praise of his glory."

One primary truth God is teaching me is that there is no way to become his masterpiece without spending time with him. This painting is titled *Holy Encounter* and depicts the scene in Exodus 24 when Moses responds to God's command to visit him on Mt. Sinai. There, he had a holy encounter with God that lasted forty days. Moses had numerous lengthy encounters with God as he led the Israelites to the Promised Land. Given the size of the job, I'm sure God knew how much Moses needed those lengthy holy encounters!

Now, I have never had a forty-day intensive holy encounter with God, but he is teaching me I cannot write a devotional or paint a painting that glorifies him if I don't make time for daily encounters with him. I've noticed throughout the book of Exodus the phrase, "The Lord said to Moses" is repeated over and over. This repetition tells me that 1) Moses was actively listening for God's voice, and 2) these ongoing holy encounters enabled Moses to fulfill his calling. God used both the lengthy and the daily encounters to transform Moses from a murderer running from justice into one of God's greatest masterpieces. A masterpiece who was with Jesus during his transfiguration (Matthew 17) and who Paul listed in the "Faith Hall of Fame" in Hebrews 11.

I'm a bit of a slow learner, but God is teaching me that I, like Moses, need holy encounters with him—lots of them. If my top priority is spending time with him daily (maybe forty minutes instead of forty days!) and if I actively listen for his voice throughout my day, he will use those encounters to slowly transform me. I'm not there yet; I have a long way to go. Becoming his masterpiece is a lifelong journey and I won't complete the transformation during my time on earth. I know, however, when I reach my heavenly home, God will have already taken all of my mistakes and imperfections and covered them with his love and grace. He will have purified my unique gifts and experiences with Jesus' blood. When I meet him face to face, I will finally be his completed masterpiece. God has the same adventure waiting for you. Let's take the journey together.

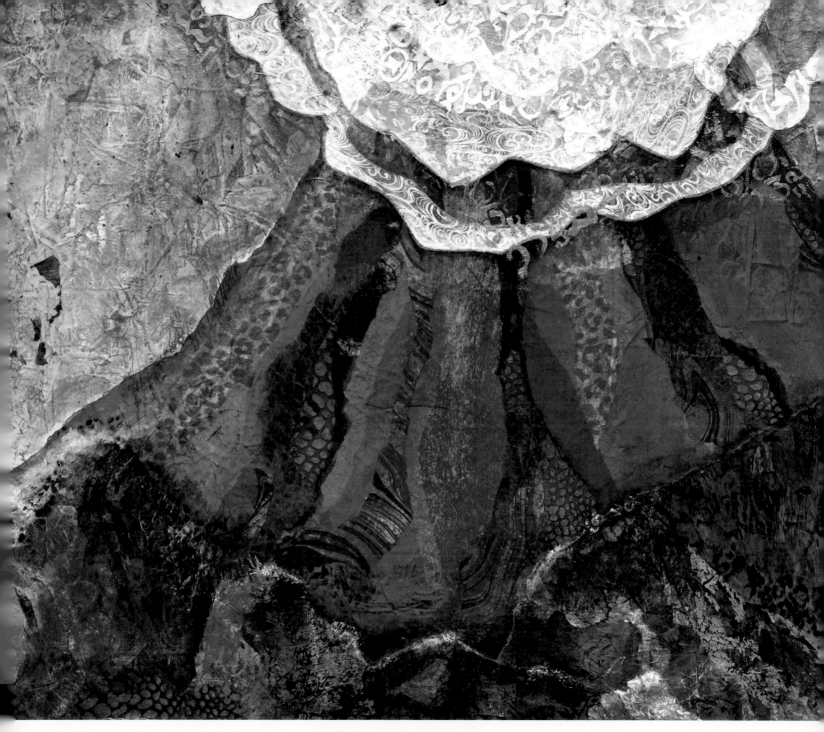

HOLY ENCOUNTER

"When Moses went up on the mountain, the cloud covered it,
and the glory of the Lord settled on Mount Sinai." Exodus 24:15-16a

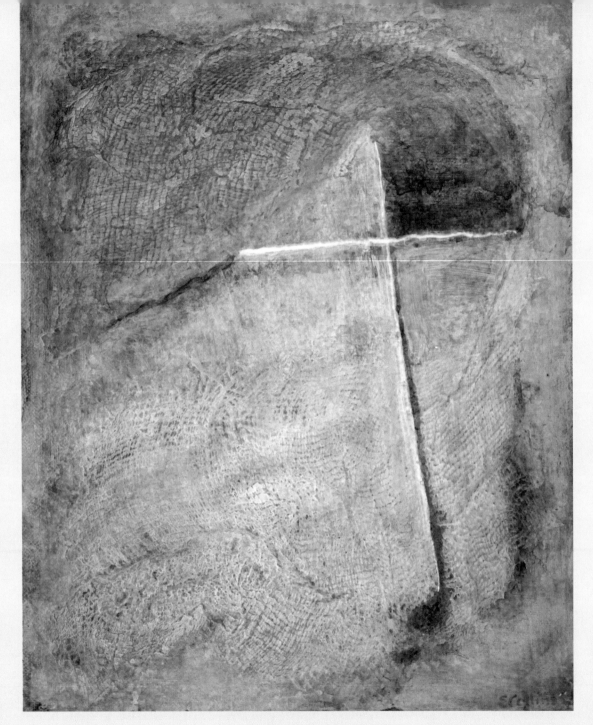

HOLY WIND

"Suddenly a sound like the blowing of a violent wind came from heaven
and filled the whole house where they were sitting." Acts 2:2

LIVING IN DEPENDENCE

As I began to learn to paint, God decided it was time to teach me a few lessons. Not art lessons—life lessons!

First and foremost, he began teaching me to live "in dependence" on him. Please note the short space between "in" and "dependence." Take that space away and you have independence. Now as an American, I love independence. I was raised with the great American value of self-sufficiency. I hate to tell you, but that just ain't biblical!

He is teaching me I cannot paint a decent painting or write a worthwhile devotional unless I am totally dependent on him. I've learned that within that small space between "in" and "dependence" are two very important things—seeking and waiting.

Let's tackle seeking first. Seeking is earnestly pursuing God. Legitimate seeking involves spending time in his Word and in prayer. Being a task-oriented person who likes to get things done, I have been known to do more of the "take a peek at God" approach: read the two-minute devotional, recite my list of requests to him with one eye on the clock, and then out the door!

God is supposed to be my first love. Matthew 6:33 says, " seek first his kingdom and his righteousness." I'm just here to tell you that my two-minute approach doesn't really reflect "first love." It's more of a weak "like."

Okay, seeking is hard enough, but the second—waiting—oh dear! I am not a fan of waiting. When I am painting and I am stuck (happens a lot!) sometimes I know God wants me to stop painting and wait for further instructions. When I give him a couple of seconds to respond and then just plow ahead, I invariably end up with a hot mess. The Bible Gateway website says the Bible (NIV) includes the word "wait" 129 times. That's an indication that waiting may be something that's important to God. Psalm 27:14 says, "Wait for the Lord; be strong and take heart and wait for the Lord." I am slowly learning when God says, "stop" I need to set that painting aside and move on to something else and wait on him.

This painting, Holy Wind, is an example. I can't even describe how ugly it was when I was relying on myself to get it done. When I finally stopped, sought his help, and waited for him, God gently guided me out of my mess.

But wait! Could seeking and waiting also apply to other areas of my life? 1 Chronicles 16:11 says, "Look to the Lord and his strength; seek his face always." The word "always" just might give us the answer.

Seeking and waiting—keys to living in dependence. Easy to say, impossible to do without the power of the Holy Spirit—but that's another devotional, I think!

ROAD FRUIT

Galatians 5:22-23 says, "But the fruit of the Spirit is love, joy, peace, forbearance, kindness, goodness, faithfulness, gentleness, and self-control. Against such things there is no law."

I will get back to that verse in a minute, but let me first set some modern-day context. I live in Houston, Texas where we have traffic with a capital T. We have the dubious honor of having the widest stretch of highway in the world—Interstate Ten with twenty-six lanes (includes frontage roads). I live about one mile from this wonder of the world and can tell you that despite its vast size, it is often totally clogged with traffic. While I haven't yet experienced road rage on this slab of concrete, I often experience road annoyance and irritation. Incredibly I find almost no one is driving the way I think they should! They are either too slow (the speed limit) or too crazy fast. Often, the kindest words out of my mouth are "idiot" and "moron."

So back to our verse in Galatians. Wouldn't dealing with traffic be so much easier if we all exhibited the fruit of the Spirit while driving? I think if I was able to genuinely demonstrate patience, kindness, goodness, faithfulness, gentleness, and self-control, then the love, joy, and peace would follow. A couple of observations about this verse:

- We don't get to cherry-pick (cute pun, huh?) which fruit we will "specialize" in. Both the noun and verb in this verse are singular so it's pretty much an all or nothing deal.
- We also don't get to cherry-pick which moment we demonstrate this fruit. Prior to this verse, the apostle Paul tells us to walk in the Spirit. He says nothing about walk in the Spirit when things are going your way or only walk in the Spirit when times are tough. God desires for us to walk in the Spirit and bear his fruit all of the time.
- It is fruit of the Spirit, not the fruit of my own grit and determination and will-power. If I try to be fruitful through my own strength, failure ensues—as evidenced by my responses to Houston traffic! It is only through the power of the Spirit that we have any chance of living this out.
- God wants the fruit of the Spirit to sweeten our encounters with others, just like apples, pears, and berries sweeten our meals. In trying to visually portray the fruit of the Spirit, I found that painting the concepts of love, joy, peace, etc. to be pretty darn impossible; so I went with a pear and berries in *Spirit Fruit*!

You may not have to deal with Houston traffic but all of us have something that tests our own limits of love, joy, peace, patience, kindness, goodness, faithfulness, gentleness, and self-control. I have absolutely no control over the way other people in Houston drive, but I do have a power within me (the Holy Spirit) that can help me respond without annoyance and irritation and ugly words. I just have to invite him to help me experience Road Fruit! I'm going to try to remember that the next time some jerk (oops!—I mean, child of God) cuts me off.

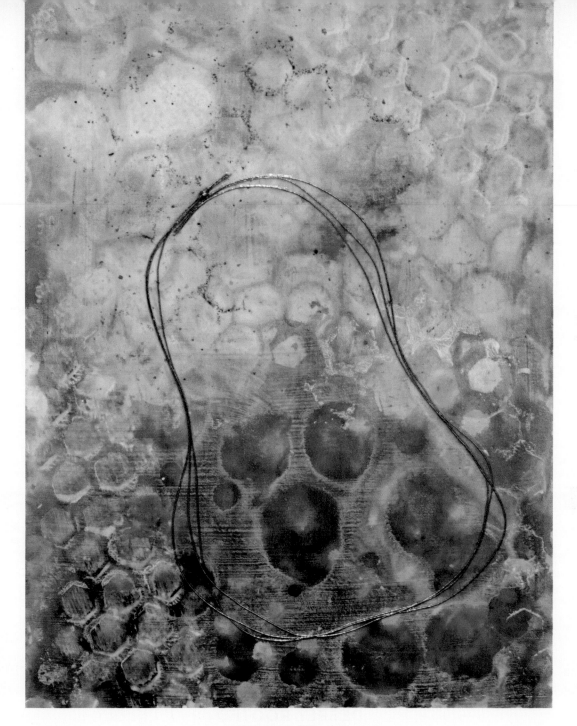

SPIRIT FRUIT

"But the fruit of the Spirit is love, joy, peace, forbearance, kindness, goodness, faithfulness, gentleness and self-control." Galatians 5:22-23

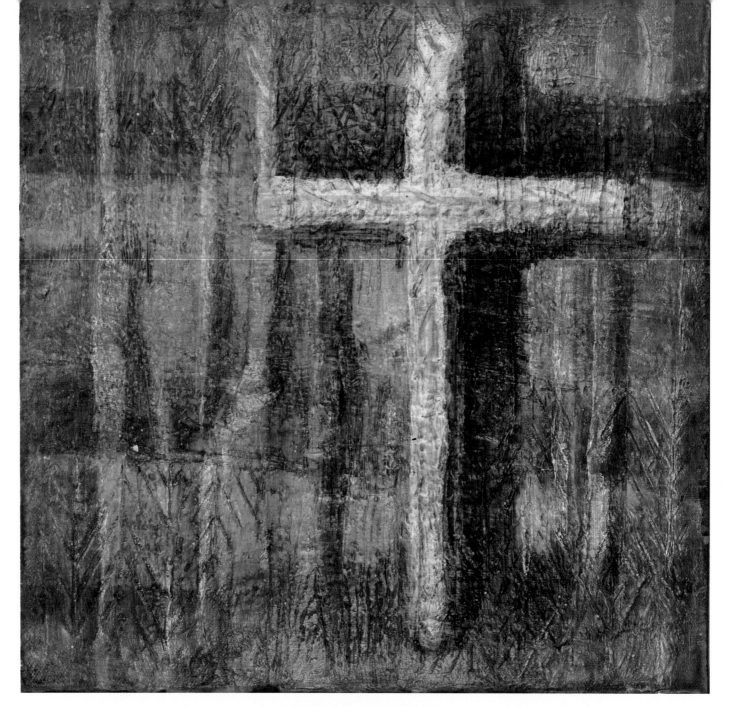

DEEPLY ROOTED

"So then, just as you received Christ Jesus as Lord, continue to live your lives in him, rooted and built up in him, strengthened in the faith as you were taught, and overflowing with thankfulness."
Colossians 2:6-7

DEEPLY ROOTED

This painting is called *Deeply Rooted* and in my search for a Bible verse to go with this painting, I found two equally great contenders:

- Colossians 2:6-7 says, "So then, just as you received Christ Jesus as Lord, continue to live your lives in him, rooted and built up in him, strengthened in the faith as you were taught, and overflowing with thankfulness."
- Ephesians 3:17-18 says, "And I pray that you, being rooted and established in love, may have power, together with all the Lord's holy people, to grasp how wide and long and high and deep is the love of Christ."

The apostle Paul is clearly stating that being rooted (in Christ and his love) is important to our spiritual health. Being rooted and established is also important for plants to thrive. Deep, established roots are key to the plant's health.

Now, I am not a good gardener. My house is more a place where plants go to die instead of thrive. The reality is that I know the basics of what to do (good soil, water, feed, prune, etc.). It is a problem of not consistently following through on what I know to do. My plants suffer from benign neglect, thus many of my plants tend to have relatively short lifespans.

It should come as no surprise then, that I am often not a very good "gardener" when it comes to my spiritual "garden." I know what it takes to thrive as a Christian (prayer, worship, Bible study, community with other Christians) but I don't always consistently follow through and spiritual withering ensues. As I look at the verses above, the benefits of healthy spiritual roots are pretty awesome:

- My faith will strengthen.
- I'll be so full of thankfulness that it overflows.
- My relationships with fellow believers will deepen.
- Best of all, I will experience the extravagant love of Christ in ever deeper ways.

Do I really want to miss out on these riches that God has waiting for me? In reality there is no such thing as benign neglect when it comes to our relationship with God. The consequences of neglect are far from benign—they are eternal. Time to get to tending those roots!

CIRCLE DANCE

I recently had the privilege of attending an art workshop in Santa Fe, NM. For one of our projects each participant was to create a piece focused on our ancestors. Frankly, I don't know much about my ancestors. Once I get past my grandparents, I'm pretty much in the dark about family history. So I started thinking about my spiritual ancestors. Ok, there was Martin Luther and then . . . ? I did think about Abraham and Moses and the apostles, but then thought if I'm going back that far, I might as well go back to the ancestor of all of us—God.

Now, who can paint God? Michelangelo painted God in the Sistine Chapel but I'm not quite up to his level yet! It's also hard for me to think of God without thinking of the Trinity (Father, Son, and Holy Spirit) and it's even more difficult to consider painting the Trinity!

Greg Ogden wrote of a beautiful concept of the Trinity in his book, Essential Guide to Becoming a Disciple, which focuses on Matthew 28:18-20: "All authority in heaven and on earth has been given to me. Therefore go and make disciples of all nations, baptizing them in the name of the Father and of the Son and of the Holy Spirit, and teaching them to obey everything I have commanded you. And surely I am with you always, to the very end of the age."

Ogden's concept is that the three members of the Trinity are in eternal fellowship together in a circle dance. I find that to be an intriguing and compellingly beautiful visual concept. Another aspect of the circle dance is that upon baptism, believers are invited into that holy circle dance, eternally in fellowship with the perfect love of the Trinity. To the extent I can wrap my head around this, I am filled with a profound sense of awe and wonder. The beautiful thing about circle dances is they generally occur at joyous occasions (weddings and Greek restaurants!) and there is always room for one more. So with that in mind, I began to explore how to paint a circle dance.

I decided to use three interlocking circles to represent the Trinity but left one circle open and extended as a reminder that there is always room for more. You'll notice I left the background a bit dark. While we are still residents of earth, we will still have problems. However, in the midst of problems, we can still experience joy—a taste of what we will experience perfectly in eternity. Remembering we are part of the circle dance and focusing on our most ancient of spiritual ancestors can move us into joy regardless of our earthly circumstances. So when times are tough put on those dancing shoes and remember who you are dancing with!

"You make known to me the path of life; you will fill me with joy in your presence, with eternal pleasures at your right hand" (Psalm 16:11).

CIRCLE DANCE

"You make known to
me the path of life;
you will fill me with
joy in your presence,
with eternal pleasures
at your right hand."
Psalm 16:11

HOLY

"But just as he who called you is holy, so be holy in all you do." 1 Peter 1:15

ORDINARY HOLINESS

Since I painted a picture titled *Holy*, I thought I should write a devotional on Holiness. What was I thinking? It was crazy to title a picture "Holy"—who can paint holiness? To write about holiness, I discovered, is totally intimidating. For starters, I'm not sure I know much about holiness at all. I am certain it is not an adjective that my family and friends would use to describe me. In fact, I am laughing as I write this sentence!

Nevertheless we are called to holiness. Leviticus 11:44a says, "I am the Lord your God; consecrate yourselves and be holy, because I am holy." I think it boils down to this: having been created in God's image, we are to act as he acts so he can relate to us and we to him. The problem is that God is divine and perfect, and I am most definitely NOT! Thank goodness that through Christ's work on the cross I am seen as holy by God. 2 Timothy 1:9 says, "He has saved us and called us to a holy life—not because of anything we have done but because of his own purpose and grace. This grace was given us in Christ Jesus before the beginning of time."

Our holiness is a mysterious gift that assures our worthiness to be in relationship with God for eternity. It is also a calling for us while still on earth. For me, that's the hard part. As is usual in the Christian life, it can only be accomplished through the power of the Holy Spirit in us and involves the usual disciplines of prayer and Bible study. But is that it?

Recently, my two oldest grandsons, Harrison and Cash, were participating in a swim meet. I went to watch them swim and to help "wrangle" their little brother, Lane. We were doused by frequent downpours during this swim meet. During the first downpour, I wrapped Lane in a towel and he fell asleep in my arms. I found a place to sit, held an umbrella over us, and he slept through several more downpours, loud starter pistols, and cheering parents—about two hours. We were both soaked to the skin!

Later, as I was thinking about his nap time, it occurred to me that it was a sacred time—a sweet privilege and holy gift from a loving God. Perhaps sacred moments aren't reserved just for the big, well-orchestrated events—marriage ceremonies, Easter and Christmas services, Holy Communion, etc. I think God provides us with many sacred moments to catch a glimpse of his holiness in the ordinary—a sunset, a phone call with a friend, a meal shared, the song of a bird, a hug from a child. The list could be endless!

Perhaps asking the Holy Spirit to open my eyes to the sacred and holy that is all around me is part of my journey to holiness. I think it is worth a try! How about you?

WHO AM I?

*M*y husband, Ron, declared that the name of this painting was *Firmament*. I had a couple of other names in mind, but Ron was adamant its name was *Firmament*, so *Firmament* it is. The Bible verse that kept running through my head while working on this painting was Psalm 8:3-4, "When I consider your heavens, the work of your fingers, the moon and the stars, which you have set into place, what is mankind that you are mindful of them, human beings that you care for them?"

This is clearly a question that has puzzled the generations. It seems like the God of the universe would be way too busy to be concerned with what is going on with me.

I am fascinated by the pictures that have come back from the Hubble telescope as it has traveled into deep space. The images are profoundly beautiful and awe inspiring. The size and scope and majesty of God's creation is beyond what my brain can process, and is certainly beyond what my painting can portray.

So against this backdrop of unimaginable magnitude, let's think about you and me. On my painting we would be indiscernibly tiny and even more so in the true vastness of space. The thing that boggles my brain is that God who is busy managing the universe, knows each of us intimately and desires to have a deep and personal relationship with each of us. In Matthew 10:30, Jesus speaks of his intimate knowledge of us, "And even the hairs of your head are numbered." Isaiah 43:1b says, "Do not fear, for I have redeemed you; I have summoned you by name; you are mine." He claims each one of us personally and is deeply interested in everything about us.

How does God do this? How does he keep everyone straight? How can he give his undivided attention to me (and you!) when there are billions of people clamoring for his attention all of the time? He has to have some off-the-chart brain capacity and time management skills! When I have several grandkids with me, often all of them want to tell me something at the same time. I am totally incapable of giving my individual, undivided attention to all of them at the same time. I have to focus on one and then another . . . and even though I love them with all my heart, I have no idea how many hairs are on their heads. Clearly, I am not God!

All of this pondering leads me to acknowledge the mystery of our God whose power and love are so far beyond our comprehension. This moves me to awe, wonder, and profound gratitude.

God, who am I that you are mindful of me? I can't comprehend the scope of your love for me, but I am so deeply thankful for it. I pray today, through the power of the Holy Spirit, my gratitude will permeate all aspects of my life. Amen.

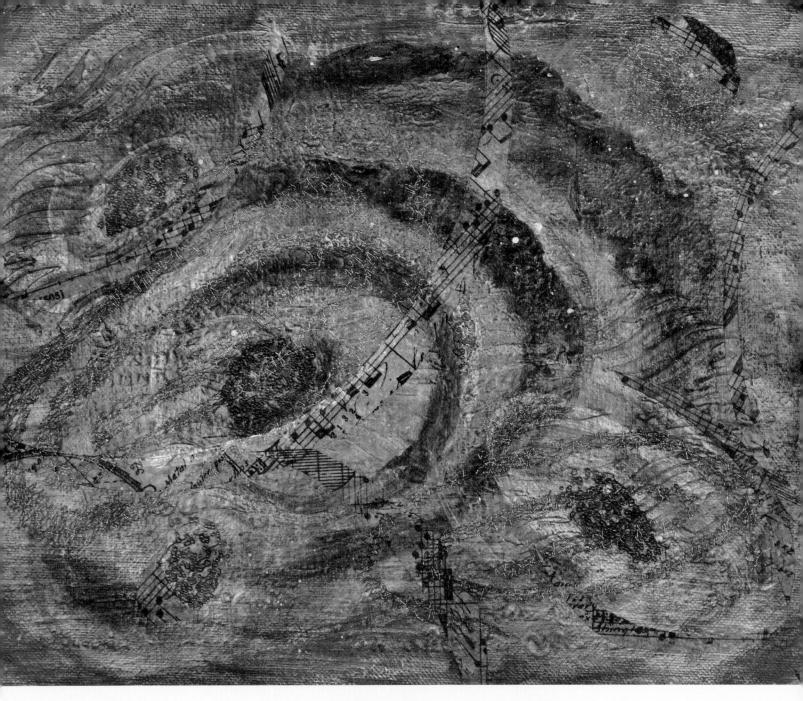

FIRMAMENT

"When I consider your heavens, the work of your fingers, the moon and the stars, which you have set into place, what is man that you are mindful of him, human beings that you care for them?"
Psalm 8:3-4

DESERT SPRING

"I will make rivers flow on barren heights, and springs within the valleys. I will turn the desert into pools of water and the parched ground into springs."
Isaiah 41:18

FREELY FLOWING

Desert Spring is one of those paintings where I wandered around in a desert of despair before it began to take shape. God had to pry my fingers off of my plans so he could pour life-giving water, his plans, into the situation. He provided both his vision for the painting and inspiration for this devotional.

"I will make rivers flow on barren heights, and springs within the valleys. I will turn the desert into pools of water and the parched ground into springs" (Isaiah 41:18).

God gave the prophet Isaiah these hopeful words not only for the Israelites centuries ago but also for us. God's promise to provide life-giving water was eternally fulfilled in his Son, Jesus. In John 4:14, Jesus says, "whoever drinks the water I give them will never thirst. Indeed, the water I give them will become in them a spring of water welling up to eternal life." In John 7:38-39, Jesus goes on to say, "'Whoever believes in me, as Scripture has said, rivers of living water will flow from within them.' By this he meant the Spirit, whom those who believed in him were later to receive."

I find three key truths here: 1) following Jesus is the way to stay well-hydrated spiritually, 2) the living water he provides us is not to be hoarded but is to be shared, and 3) the Holy Spirit enables this whole process. It is our spiritual lifecycle. His life-giving truth nourishes us, enabling us to share his life-giving nourishment with others.

Perhaps the apostle Paul was thinking of Jesus' living water when he wrote about the fruit of the Spirit in Galatians 5:22-23, "But the fruit of the Spirit is love, joy, peace, forbearance, kindness, goodness, faithfulness, gentleness and self-control." If all the people that I encounter experienced only the fruit Paul describes as the result of their interactions with me—well, that would be a miracle! The living water of Jesus would be flowing from me freely. Unfortunately, the living water in me often gets dammed up by my self-absorption and my inclination to be easily distracted from what should be my number one priority—him.

I've lately been convicted about a second component of letting that living water flow from me—opening my mouth and speaking about my faith. Even if I were to let the Holy Spirit consistently flow through me and the fruit of the Spirit were on full display, I still am called to speak about the source of that living water. The psalmist often refers to praising the source of our very existence and our hope. Psalm 89:1 says, "I will sing of the Lord's great love forever; with my mouth I will make your faithfulness known through all generations." In verse 15, he goes on to say, "Blessed are those who have learned to acclaim you, who walk in the light of your presence, Lord."

I have never been a great "acclaimer." I get scared, nervous, and tongue-tied. With the help of the Holy Spirit, I've become a tiny bit braver and made a little progress. But I have a long way to go. In Luke 9:26 Jesus said, "Whoever is ashamed of me and my words, the Son of Man will be ashamed of them when he comes in his glory and in the glory of the Father and of the holy angels." I really don't want Jesus to be ashamed of me, so I think it's time for me to get over my tongue-tied silence. It's time to speak of my faith without fear. I can't do it on my own—none of us can! But the Spirit that Jesus provides with his living water can provide me with the power and the words so his life-giving water can flow from me freely.

I wonder how our world would be changed if we all let the Spirit turn us into springs of his living water? What if people experienced only love, joy, peace, patience, kindness, goodness, faithfulness, gentleness, and self-control when they encountered us? What if we told them the source of those qualities was Jesus Christ and he could provide them with living water as well? It's what we've all been called to do and it's never too late to get started!

LIGHT OF THE WORLD

"When Jesus spoke again to the people, he said, 'I am the light of the world. Whoever follows me will never walk in darkness, but will have the light of life'" (John 8:12).

As a new painter, I am learning how critical light is to the success of a painting. With no clear source of light, a painting looks flat and uninteresting. However, when the painter establishes a light source and begins to highlight those areas where the light is shining, the painting begins to take on life. The light accentuates the beauty and vitality of the various colors and shapes. The painter then begins to add varying degrees of shadow to depict where there is just a little light or no light at all. The contrast is what gives depth and beauty to the painting.

As a follower of Christ, the light of the world, I am called to let his light shine into my life. If I respond in obedience, his light reveals the beauty of the abilities, talents, unique traits, and personality he created within me. His light also illuminates his desire for me to use these gifts for his purposes and for his glory. In *Songs of Joy*, my goal was to illustrate the clarity and joy his light brings to all areas of our lives.

Christ's light also reveals areas of darkness. His light exposes my slightly dingy areas, as well as very dark secretive areas I'd prefer left unexposed—the places where sin has set up shop. Sometimes I have become quite friendly with a particular shadow and have zero interest in getting rid of that "friend." Other times, I just want to put on blinders and totally deny a particular shadow even exists.

John 12:46 says, "I have come into the world as a light, so that no one who believes in me should stay in darkness." Jesus accomplished this on the cross as he paid the price for all my darkness and clothed me in his light.

I don't know about you, but I didn't just automatically stop sinning the moment I became a Christian. Christ lets me choose how I respond to what he did on the cross for me. I can choose to not expose myself to his light and stop reading his Word and praying. I can stop being in the community of other believers. I can choose to continue to live with areas of darkness in my life.

Or out of gratitude for Christ's mercy and grace, I can let his light gently soften my heart and teach me how to say no to those "friendly" sins. For me, this is not a one-day transformation! I fall off the wagon, and he gently dusts me off and encourages me. Then, boom, off the wagon again! Over time, however, I begin to see the length of time between my failures increasing ever so slowly.

Of course, when I have semi-conquered one area of darkness, Christ's light reveals another dark area—sigh! I think we all can relate to this. This will be our process for the remainder of our days on earth as we allow him to slowly remove those dark places in our "masterpiece."

You see, God's idea of a beautiful masterpiece is different than our earthly standard. Revelation 22:5 says, "There will be no more night. They will not need the light of a lamp or the light of the sun, for the Lord God will give them light." God's beauty is full of light. There is no darkness at all—no shadows, no sin. I think his light is beyond what we can imagine and its beauty will fill us with delight for eternity. I'm hoping that when I get to heaven, he will let me try to paint it!

SONGS OF JOY

"Satisfy us in the
morning with your
unfailing love,
that we may sing
for joy and be glad
all our days."
Psalm 90:14

BREAD OF LIFE

"For the bread of God is the bread that comes down from heaven and gives life to the world."
John 6:33

HUNGRY YET?

For a good chunk of my Christian life I had trouble relating to the sentiments below:
- "Blessed are those who hunger and thirst for righteousness, for they will be filled" (Matthew 5:6).
- "As the deer pants for streams of water, so my soul pants for you, my God" (Psalm 42:1).

That kind of hunger and thirst for God was for the super-religious—preachers, missionaries, etc.—not for this ordinary Christian. I knew I was supposed to spend time with God in prayer and Bible study, so I worked at it—sometimes. I tried to have the discipline to do it but if I missed a few days or weeks, I didn't really miss it all that much.

I heard a snippet of a sermon by Dr Tony Evans on the radio some time ago. He said many people think they get adequate spiritual nourishment from listening to a sermon once a week. Dr Evans said a sermon is just an appetizer—it's not a meal. The appetizer is just supposed to whet your appetite for the meal. Your spiritual meal involves daily encounters with God through prayer and Bible study. His point was that if all the spiritual nourishment you are getting is a sermon once a week, you are on a starvation diet!

I certainly have had times in my life when I was just eating appetizers and starving myself. Jesus said, "I am the living bread that came down from heaven. Whoever eats this bread will live forever. This bread is my flesh, which I will give for the life of the world" (John 6:51). He is our nourishment, a feast given from the Father above. Why in the world did I spend so long not realizing how famished I was?

I think the world offers us all kinds of junk food we think will fill us and nourish us. Many of these things are not inherently bad, but they have limits on how much nourishment they provide to our souls—family, career, financial security, hobbies, travel, etc. We fill up on these things and we feel full for a while. It's like eating a bag of potato chips: tastes really good, fills you up for an hour or so, but nutritionally pretty much a zero.

In *Bread of Life*, I wanted to show the contrast between the world's junk food (suggestion of a dark, rustic loaf with a just enough sparkle to lure us in) and the glow from our source of true spiritual food, Jesus Christ. Every day we have choices to make!

I'm not sure exactly when I started to feel hunger for more than my sermon appetizer once a week. God, in his mercy, took my sporadic "eating" habits and began to change my heart. He began to put a desire in me to spend time with him, not because I was supposed to but in response to his love and desire to spend time with me. It really is like being served a delicious, nutritious banquet every time we just focus on God and his Word. Psalm 107:8-9 says, "Let them give thanks to the Lord for his unfailing love and his wonderful deeds for mankind, for he satisfies the thirsty and fills the hungry with good things."

Now, I don't have this perfected. Sometimes I want to eat in a hurry when God wants me to linger. Sometimes I still skip a meal or two. But finally, I actually do feel hunger for him when I skip that meal. It sounds kind of weird, but I hope you are hungry too!

PROPHECIES FULFILLED!

As we head toward Easter Sunday, I have been thinking about how the events of Holy Week are so clearly the fulfillment of Old Testament prophecies of a Messiah. On Palm Sunday, I was reminded of how passionately the Jewish people longed for the fulfillment of those prophecies.

Jesus was pretty clear that he, indeed, was the promised Messiah. In Matthew 26:56, as Jesus was being arrested in the Garden of Gethsemane, he said, "But this has all taken place that the writings of the prophets might be fulfilled." After he was resurrected and was walking along the road to Emmaus, Jesus had another opportunity to explain how his life had been foretold. Luke 24:27 says, "And beginning with Moses and all the Prophets, he explained to them what was said in all the Scriptures concerning himself."

During Holy Week and specifically on Good Friday, we reflect on Christ's sufferings on the cross. Hundreds of years before this history-altering event, the words of the prophet Isaiah foretold what Christ was to endure.

- "But he was pierced for our transgressions, he was crushed for our iniquities; the punishment that brought us peace was on him, and by his wounds we are healed" (Isaiah 53:5).
- "He poured out his life unto death, and was numbered with the transgressors. For he bore the sin of many and made intercession for the transgressors" (Isaiah 53:12).

Through the fulfillment of these prophecies, God provided the ultimate love gift to mankind. God didn't send the Messiah to solve a specific political problem or even to alleviate the legitimate physical suffering of his people. God provided a Messiah to solve the chronic human problem of sin. While God is concerned about our political messes and physical well-being, he is even more interested in our souls; so much so that he sent his Son to pay the consequences for our sin.

It is easy for me to look back at those first century folks and wonder how they missed this fulfillment of prophecy. How could they not see clearly that Jesus was their spiritual Messiah? Why couldn't they look beyond their desire for a warrior type Messiah who would rescue them from the tyranny of Rome and restore their temple and homeland?

Perhaps we too suffer from those same kind of Messiah expectations! How often do we want God's answers to our problems and concerns to be touchable and seeable—right now! I know my preference is for God to remove a problem rather than to walk beside me through the problem. And a blessing is just so much easier to recognize if I can touch it, taste it, or hear it.

Psalm 37:4-5 tells us, "Take delight in the Lord, and he will give you the desires of your heart. Commit your way to the Lord; trust in him and he will do this." When we read "desires of your heart" it is so easy for our hearts to immediately leap to the allures of this world: a new car, a bigger home, more money in the bank, or a smaller waist.

Could something be askew with the desires of my heart? Perhaps intentionally shifting my focus from the "desires of my heart" to the commands in these verses—"delight in the Lord," "trust in him," and "commit your way to the Lord," would start to right the wrongs in my heart. Through trusting, delighting, and committing to him, the "desires of my heart" start to be transformed into "his desires for my heart."

In painting *Prophecy*, my initial efforts were all about painting something I desired. Alas, a mess ensued. Not surprisingly, it was only when I focused on God's desires for the painting, that the prophet figure began to emerge from the mess! It was a gift from a generous God.

God's most extravagant gifts are for our souls and are found in the midst of our relationship with him. Those gifts are available to us because of Jesus' death and resurrection. This is cause for joyous celebration! May you have a blessed Easter!

PROPHECY

"But all this has taken place that the writings of the prophets might be fulfilled."
Matthew 26:56

35

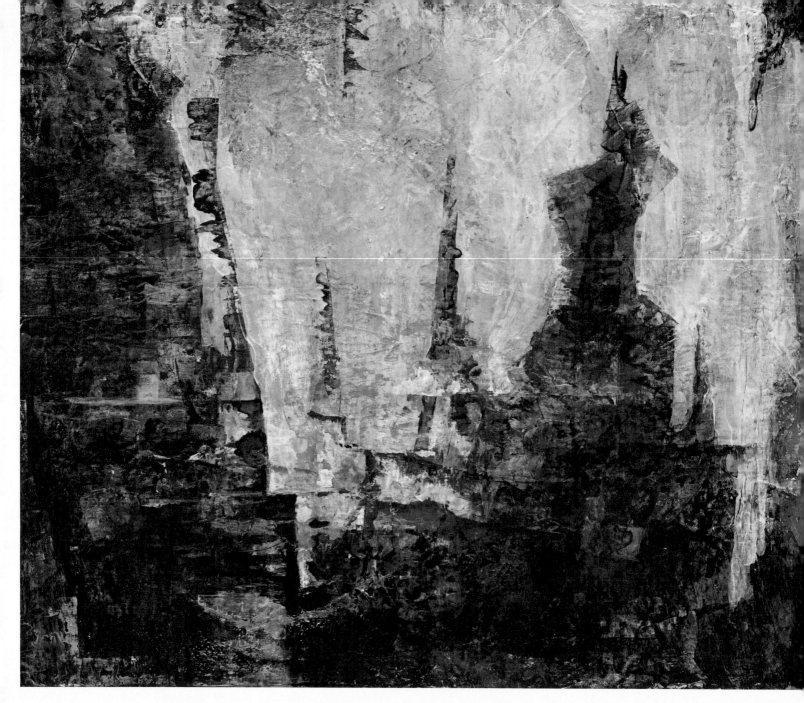

SONRISE

"We also have the prophetic message as something completely reliable, and you will
do well to pay attention to it, as to a light shining in a dark place,
until the day dawns and the morning star rises in your hearts." 2 Peter 1:19

A REFRESHING MATTER OF MAGNITUDES

We have now completed Lent, Holy Week, and Easter Sunday. As always, revisiting Christ's journey to the cross and out of the tomb seems to re-awaken, refresh, and even deepen my gratitude for the mercy and grace we have been given in him. Once Easter is over, however, I seem to lose that sense of fresh awe and wonder at the magnitude of God's love for us. In 2 Peter 1:12-13, Peter shares the importance of refreshing our memory: "So I will always remind you of these things, even though you know them and are firmly established in the truth you now have. I think it is right to refresh your memory as long as I live in the tent of this body." Peter may have been thinking about refreshing our memories a little more often than once a year at Easter.

What gets in the way of maintaining that fresh appreciation for what Christ suffered for us? My problem, I think, is a problem of maintaining a proper perspective on magnitudes: the magnitude of my need for a Savior and the magnitude of the love and mercy I have been given.

It is very easy for me to take it all for granted. When I dig to the bottom of that issue, I find a problem with minimizing the sin in my life. Our culture tends to categorize sin by size (white lies vs. whoppers). I'm not sure the Bible supports this perspective on sin! James 2:10 says, "For whoever keeps the whole law and yet stumbles at just one point is guilty of breaking all of it." This leads me to believe that from God's perspective, any sin is abhorrent to him, regardless of how big or little we may think it is. I like to think my little missteps here and there are nothing compared to "whoppers" like the crimes of Hitler or the 9/11 terrorists. It is hard for me to maintain a fresh perspective and continually recognize that Christ had to die on the cross for my sin which, by the way, is just as ugly to God as the next person's.

It is only when I refresh my memory about my sin and my need for a Savior that I can have a fresh perspective on the reality of the amazing grace God provided through the cross and the tomb. Romans 5:8 is a familiar Scripture: "But God demonstrates his own love for us in this, while we were still sinners, Christ died for us." When I take that truth for granted, I trivialize the magnitude and cost of his gift.

When I was painting *Sonrise*, I was thinking about challenging myself to take a moment each morning to refresh my thinking about "magnitudes." 2 Peter 1:19 says, "We also have the prophetic message as something completely reliable, and you will do well to pay attention to it, as to a light shining in a dark place, until the day dawns and the morning star rises in your hearts." Peter tells me that to get a reliable perspective, I must go to Scripture. Its light will remind me of the magnitude of my sin and the brilliance of Jesus' priceless gift.

I love the thought of Jesus, our Morning Star, rising in my heart each morning as I seek an accurate "magnitude reading." What better way to keep the fresh gratitude and joy of Easter in our hearts? I pray that through the power of the Holy Spirit, each of us can daily re-experience the wonder of the resurrection so we can be lights "shining in a dark place."

BE STILL

"Be still and know that I am God" (Psalm 46:10a).

I don't know about you, but I have trouble being still, especially when it comes to spending time with God. I have always been a very task-oriented person, so I tend to approach my quiet time with a spiritual to-do list: read "Devotional Book One," check; read "Devotional Book Two," check; pray using my mental (sometimes written) checklist of people and things to pray for and about, check. Oops, forgot to be still and listen to God. Back to the task: listen for thirty to sixty seconds—done!

I don't think this was what the psalmist had in mind when he wrote the verse above. The truth is that in order to know God and to hear him, we need to be still. Often God speaks in a gentle whisper (1 Kings 19:12) and usually I am too busy blabbing and "to-doing" to hear his voice.

So this week I thought I'd paint a picture based on Psalm 46:10. I started by writing the verse on a blank canvas. I also wrote words like peace, calm, quiet, rest, and joy—benefits that come from listening to God. I painted the whole canvas orange (which is not a restful, quiet color). My idea was that I would paint an energetic, vibrant picture and then would overlay it with more calming, quiet colors like blue and green. Unfortunately, even after I applied the cooler colors, the painting just didn't feel like it was communicating "be still." Not surprisingly, I then sensed the Holy Spirit saying, "just stop" and even more surprisingly, I did just that. I put the painting on our mantle and just let it sit for a while. As I studied the painting, I began to realize the painting wasn't going to be about being still, it was about the love of Christ expressed in Ephesians 3:17-18: "And I pray that you, being rooted and established in love, may have power, together with all the Lord's holy people, to grasp how wide and long and high and deep is the love of Christ."

I worked some more on the painting and titled it *Deep*. I began to notice that as I gazed at the painting, the Holy Spirit would call me into contemplation of the expansive and deep love of Christ for me. I found myself being still and being receptive to his voice. Maybe this painting is about being still after all.

I try to jump in our pool most mornings and check off my work-out on my to-do list. After a nudge from the Holy Spirit, I have recently started working out in silence—no music. I have tried to use this time as an opportunity to be still spiritually (not bodily since my arms and legs are churning under the surface!). My goal is to use this time to intentionally listen. Now, my mind can and does roam and wander far away from him, so I have not yet mastered this still/listening time.

There was very little breeze this morning as I was doing my "still time." I noticed if I kept looking around the yard, I could always find a tree branch or leaf that was being moved by an unseen breeze. I think God is like that breeze—he is always moving and speaking but if I don't quiet myself and intentionally listen for his gentle whisper, I might miss what he wants to share with me. God just might want to tell me how deeply he loves me. I'd hate to miss that.

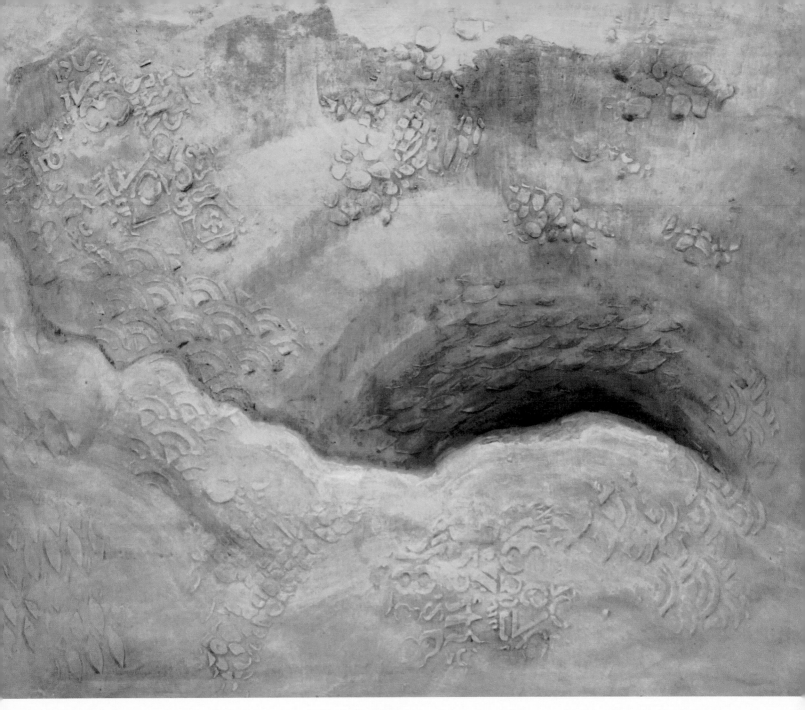

DEEP

"And I pray that you, being rooted and established in love, may have power, together with all the Lord's holy people, to grasp how wide and long and high and deep is the love of Christ."
Ephesians 3:17-18

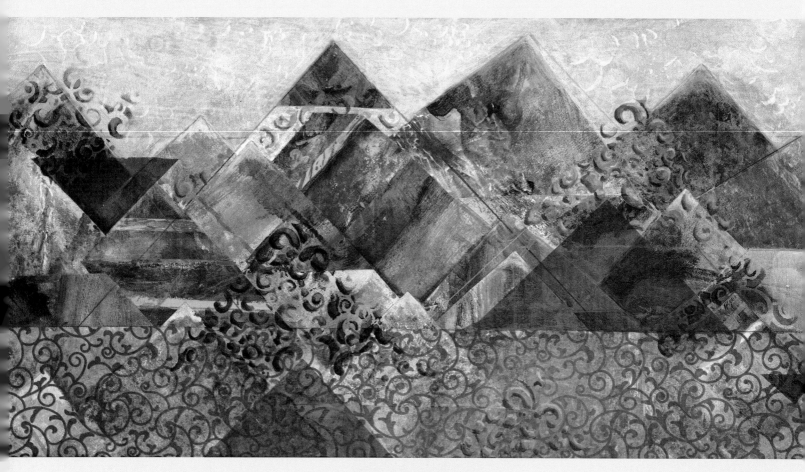

MOUNTAIN SONG

"Let the rivers clap their hands,
let the mountains sing together for joy."
Psalm 98:8

JOY IN THE MORNING

"Weeping may stay for the night. But rejoicing comes in the morning" (Psalm 30:5).

"You make known to me the path of life; you will fill me with joy in your presence, with eternal pleasures at your right hand" (Psalm 16:11).

I am sure we all wake up every morning just overflowing with joy. Mmmm, maybe not. The reality of our lives is that often we wake up with fear or anxiety racing in our brains, or with pain of some kind—physical, emotional, or relational. Our circumstances often don't sing a melody of joy to us when we open our eyes in the morning. Sometimes the morning starts off well enough but somehow, we lose the joy as the day progresses and we find ourselves sad or angry. God's Word promises us joy, but how do we get there?

Our priorities might be the key. Deuteronomy 6:5 says, "Love the Lord your God with all your heart and with all your soul and with all your strength." Loving God with all my heart, soul, and strength involves trusting he loves me enough to want what is best for me. Out of that trust, my love for him inspires me to obedience and thanksgiving and generosity. That would be in a perfect world, where I love Him 100% of the time with 100% of my heart, soul, and strength.

Clearly, I won't reach that level of perfection until I am in my heavenly home, but Psalm 16:11 promises that in this life he will fill us with joy in his presence. The key phrase is "in his presence." Now God is present with me (and you) every second of every day, but am I present with him? Is my focus on pleasing him or on pleasing me?

I find if I am not loving God with all my heart, it is because I am busy worshiping another "diety." In a sermon I heard a number of years ago, the minister asserted that if we aren't worshipping God with our all, we are usually worshipping the "unholy trinity": me, myself, and I. Ouch! That comment hit too close to home.

I actually started out this morning feeling pretty joyous. Then I started working on this devotional and it just wasn't flowing. I had to leave it for a while to go get my annual mammogram (not my favorite outing). After a much longer wait and more painful procedure than usual, I headed to the grocery store to pick up a couple of items. The store was in the midst of a total reorganization, which meant I didn't know where to look for things. When I finally located a couple of my items, they were out of stock. I found myself totally irritated and out-of-sorts over this "conspiracy" to make my life miserable!

It is really ironic, because we fool ourselves into thinking what we want will meet our needs, satisfy us, and bring us joy. Any satisfaction we get is short lived, the unholy trinity's appetite is voracious, and our self-centered wants grow and grow. When things don't go our way, irritation and disappointment grow into anger and bitterness.

There is no joy in the presence of the unholy trinity! I wanted a stress-free, easy afternoon, but maybe God wanted me to experience joy by seeking him in the midst of the delays and frustrations. Perhaps there was someone to whom he wanted me to say a kind word or someone who needed assistance navigating through the grocery store. I think I would have found joy in those, but I was too wrapped up in my self-centered irritation.

God alone is the source of our joy and it is available morning, noon, and night. This painting, *Mountain Song*, is my take on what it would be like to experience his joy all day long. Everything in my day would be tinted by the glow of his presence. Only he can provide joy in the midst of sorrow, pain, and less than ideal circumstances. He is already with us. We just have to choose him over ourselves. Hard to do, but his Spirit is ready, willing, and able to assist. We just have to ask.

WHAT ARE YOU WEARING?

"Therefore, as God's chosen people, holy and dearly loved, clothe yourself with compassion, kindness, humility, gentleness and patience. Bear with each other and forgive one another if any of you has a grievance against someone. Forgive as the Lord forgave you. And over all these virtues put on love, which binds them all together in perfect unity" (Colossians 3:12-14).

Recently I packed for a two-week vacation and spent a great deal of time planning my wardrobe for the trip. I laid out a variety of tops, pants, dresses, and jackets on the bed. I experimented with various combinations of items, thinking about day and evening options. I evaluated what shoes would work with the various outfits. I picked out necklaces, bracelets, and earrings to coordinate with my choices. All of this wardrobe preparation took the better part of an afternoon and then I had to pack it all and see if I was under the airline weight limit!

I read the verse above when I returned from my vacation and I thought about how much effort I had put into my wardrobe for the trip. Not only did I spend a lot of time preparing, but while vacationing, at least twice a day, I was in front of my closet working out what I would wear for the next few hours. That is a lot of time spent thinking about clothes! Embarrassingly, I am just about as bad when I am not on vacation.

It occurred to me that perhaps I should be spending at least as much time preparing for and thinking about the spiritual clothes I wear each day. As believers, we can shed our old, dirty, and tattered clothes; garments like pride, envy, hate, bitterness, worry, and fear. As new creations, God wants us to put on new outfits.

Now, I love new outfits but sometimes I save them for special occasions instead of wearing them every day. For my routine days, I often grab the same old things to wear. They are way past their prime and they don't make me look too great, but I have grown comfortable with them. It's the same with my spiritual clothes, I keep donning those ugly old things.

God has given us a beautiful new outfit he wants us to wear every day. It's a layered look! It includes compassion, kindness, humility, gentleness, patience, and forgiveness. God even gives us a "signature piece," love, that brings the whole outfit together (v. 14). He is the ultimate stylist! If we choose to put on these clothes (with the help of the Holy Spirit), then we begin to look more and more like Christ.

Just like planning my trip wardrobe, wearing our new spiritual clothes takes some effort. We need God's help to put on the new clothes and keep them on! Spending time in his Word and in prayer helps us get "dressed" in our new clothes and enables us to pack a "spiritual backpack" with a few extras. Now, many days I start out in my beautiful new clothes but then something challenging occurs and I shed those new clothes and put on my ugly ones. If I am prepared, I am more likely to choose to send up a quick prayer asking the Holy Spirit to help me use the clothes in my backpack rather than continuing on in my dirty rags!

When I painted *Wardrobe*, I didn't have this verse in mind. I painted it for a friend who had family members impacted by a flood as the result of Hurricane Harvey here in Houston. Although her house didn't flood, her life was completely overwhelmed with helping her family through that crisis. As we reached the one-year anniversary of the hurricane, I gave her this painting and was inspired to put this verse on the back. She put on God-given beautiful new clothes as she helped her family muck out their homes and put their priorities and needs above her own for close to a year. Did she do this perfectly? No. None of us will ever walk through our challenges perfectly, but she was an example to me of consistently choosing to wear those beautiful new clothes. I pray that you and I will do the same!

WARDROBE

"Therefore, as God's chosen people, holy and dearly loved, clothe yourself with compassion, kindness, humility, gentleness and patience." Colossians 3:12

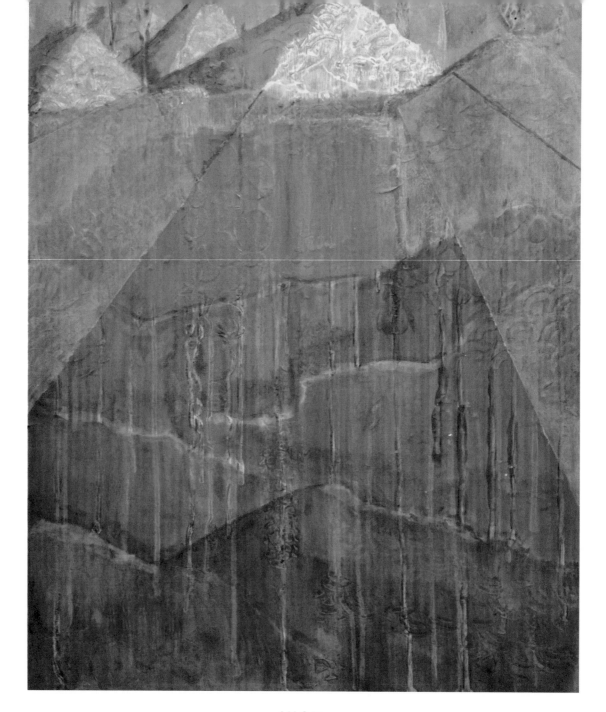

HIGH

"And I pray that you, being rooted and established in love, may have power, together with all the Lord's holy people, to grasp how wide and long and high and deep is the love of Christ."
Ephesians 3:17-18

WIDE, LONG, HIGH, AND DEEP

*E*arlier this week I had a bit of a pity party for myself. After being under the weather for several weeks with bronchitis, I was having a few "woe is me" moments thinking I was never going to get my energy level back. Our mighty God took a few minutes of his time to give me a gentle reminder. This is my paraphrase: "Hello! You are painting a series on the width and length and height and depth of Christ's love. Why not think about that for a while and get this pity party over with?" So I did.

It is easy to lose perspective when faced with one of life's trying situations. It doesn't have to be a huge life challenge for me to get off track (evidenced in the paragraph above!). I think the apostle Paul knew we would need a reminder that Christ's love is with us always, especially when we are in the midst of trying circumstances. In Ephesians 3:17-18 he wrote: "And I pray that you, being rooted and established in love, may have power, together with all the Lord's holy people, to grasp how wide and long and high and deep is the love of Christ."

Some situations seem totally overwhelming and so broad and wide that they completely surround us. It is hard to sense any way out. Christ's love is wider than the horizon. I picture his arms as broad enough to stretch around the world (or the universe!) yet close enough to envelope me in a warm hug. Sometimes his hug is just what we need to regain perspective on an issue.

Issues facing us can seem to go on forever (my one month "issue" is hardly a good example!). We can't see any resolution and we just don't feel we have the endurance that is required. Ephesians 3:17-18 tells us Christ's love is longer than any "forever" problem we are facing. His love stretches from before the earth was formed to eternity and he is with us each step of our long road.

Some circumstances challenge us mentally, physically, and/or spiritually; we have a "mountain" to climb. We feel too weak or tired or unskilled or inadequate for the task at hand. Yet Christ's love is higher than the highest mountain. His love reaches to the heavens and is there to strengthen and sustain us as we ascend the "mountain" we face.

Some problems can pull us down into the depths. Despair and discouragement color our perspective of the problem. We don't seem able to crawl out of the deep hole in which we flounder. Yet, Christ's love is deeper than any abyss. Out of his deep, deep love for us, he descended into the very deepest abyss and returned triumphant. He is there with us when we are in the depths and will guide our way out.

Before his crucifixion, Jesus promised his disciples they would receive the Holy Spirit—a comforter and counselor. He told them the Spirit would "guide you into all truth" (John 16:13). When we are facing tough situations, it is easy to lose perspective and forget that we too can ask the Holy Spirit to guide us into the truth. The truth is Jesus' love is with us, in us, and all around us, regardless of the width, length, height, or depth of our situation.

I suspect I'm not the only one who occasionally loses perspective when faced with life's challenges. I needed to remember the scope of Christ's love for me earlier this week. My prayer is that you will also vividly experience the width and length and height and depth of Christ's love!

YEARNING

First of all, I want you to conjure up a mental picture of a two-year-old child who has a treasure in her hand you want her to relinquish. Trying to get that treasure out of that hand may have to include prying little fingers off of the treasure. Hold on to that mental image and we'll come back to it!

Sarah Young's September 17 reading in *Jesus Always* defines the fear of God as "reverential awe, adoration, and submission to My will." After reading this, I started thinking about the word submit.

Frankly, submit is not one of my favorite words. It means I have to set aside my plans, my desires, and my will and accept the plans, desires and will of God. Romans 8:5 (NCV) says, "Those who live following their sinful selves think only about things that their sinful selves want. But those who live following the Spirit are thinking about the things the Spirit wants them to do." My sinful self is focused on me, not on God. I'm like that two-year-old with a death-grip on her treasure. I am reluctant to relinquish what my wandering heart desires even if it is not what God wants for me.

Basically, it's a trust issue. Even though intellectually I know God's plans are perfect and mine are not, I fall for the deceiver's lies that my way is best, and God's way will somehow suck the joy out of life. I say I trust in God, but my actions don't always convey that. I begin to trust in my own wisdom instead of his.

I started thinking about what it would be like if I actually yearned (nice old-fashioned word) for God's will in my life. To yearn is to have an eager and restless longing. What if I was able to maintain my focus on him consistently throughout my day, longing to do his will? What if the pronouns in my thoughts changed from "me" and "my" to "you" and "yours"? What would it be like if God didn't have to gently pry my fingers off my treasured plans? What would it be like if I immediately embraced his plans and desires for me?

I am way too weak and wishy-washy to manage this under my own power. It takes endurance to say "yes" to God's plans throughout each day. I find it pretty easy to start the morning with saying the theoretical "yes" to God in my morning prayers. But as the day goes along my "yes" turns to "no" as my thoughts revert to "me" and "my" instead of "you" and "yours."

As depicted in *Our Light*, his Spirit is available to light my way but instead I often choose to wander in the dark tangles of my own plans. He yearns to bring me out of the darkness into the light (John 12:46). The Holy Spirit is ready, willing, and able to provide the strength and endurance I need, if only I will ask! Galatians 5:16-17 (NCV) says, "So I tell you: Live by following the Spirit. Then you will not do what your sinful selves want. Our sinful selves want what is against the Spirit, and the Spirit wants what is against our sinful selves. The two are against each other, so you cannot do just what you please."

My prayer today is that I will yearn to yearn! That with all my being, I will yearn to do his will and he will no longer have to pry my fingers off of my imperfect and flawed plans and desires.

That is my prayer for you as well.

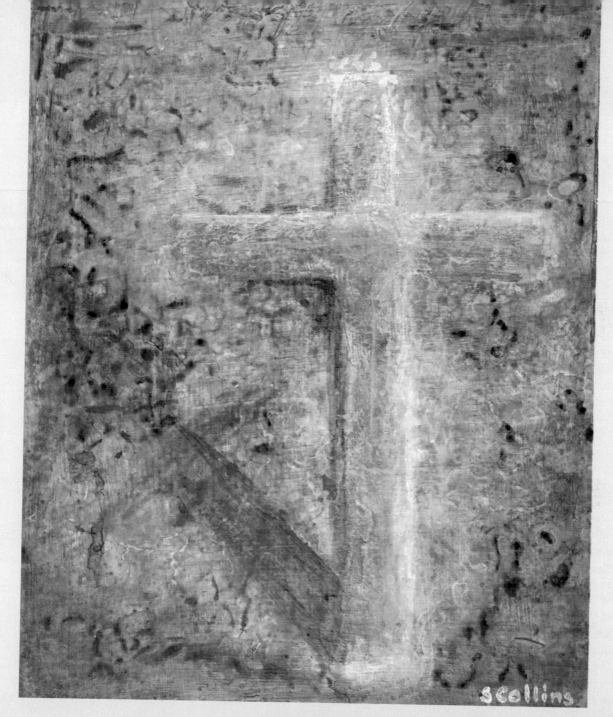

OUR LIGHT

"I have come into the world as a light, so that no one who believes in me should stay in darkness."
John 12:46

A LONG JOURNEY

"And I pray that you, being rooted and established in love, may have power, together with all the Lord's holy people, to grasp how wide and long and high and deep is the love of Christ." (Ephesians 3:17-18). When I began to paint a series on these dimensions of Christ's love, I found it relatively easy to come up with a concept for each painting except for "long." I had a really hard time conceptualizing something that would represent the immeasurable length of Christ's love for us. Ultimately God planted the idea of painting steep and almost innumerable stairs to convey a long, difficult journey.

Many of us have been on one of life's journeys that was difficult, painful, and lasted way too long. The Bible has many examples of long, difficult journeys (Abraham and Sarah's infertility, the Israelites' hike to the promised land, David's difficult and dangerous path to king, Paul's missionary journeys). There are great lessons to be learned in studying those examples. However, I am going to share a more personal journey with you.

My difficult journey was with my twin sister, Karen. It began about forty years ago, when she started displaying behaviors that began to undermine almost every aspect of her life. She was ultimately diagnosed with several mental health diseases, but the primary diagnosis was one for which there is no medication. This hideous disease wreaked havoc in her relationships, jobs, finances, and physical health. The disease sloshed over into my life as Karen went from crisis to crisis. When the phone rang, I never knew what disaster awaited.

I prayed for her frequently and fervently for years. I prayed for her healing. I wanted her to be healed quickly. I would like to say my only motive was that I wanted her to be able to experience a rich and full life. But if I am honest, that prayer was also driven by my desire to not have to deal with the mess in her life that sloshed over into mine. I was praying for my will to be done, not inquiring about God's will.

I also took on the burden of "fixing" her. I had the misguided notion that if I just said the right thing, at the right time, in the right way, she would miraculously see "the light" and would be "fixed." Just like Sarah's attempt to fix her fertility problems (read Genesis 16), I was impatient with God's timing for healing Karen. Needless to say, I never "fixed" her because I am not God. It actually was a form of idolatry to think I was capable of "fixing" her.

Throughout this journey, Christ, through his Holy Spirit, was right beside me to help me but I wasn't accessing his love, comfort, wisdom, and power. Even though I prayed constantly for Karen, I was really trying to walk this long journey on my own. My trust in God was too feeble and frail for this hard journey. I had not surrendered my will to his. I had not surrendered my timing to his timing. I had not surrendered my "fixing" to his healing. True trust in him requires all of these surrenders.

Trying to walk this long journey on my own didn't give me peace. Instead I experienced frustration, anger, sleepless nights, worry, and fear. It was only when I surrendered my desires and my timing to his that I began to experience peace.

The last few months of Karen's life were very difficult. She became unable to walk or take care of herself. She needed to be in a facility, but she had no money. I'd like to say I walked this part of our journey perfectly and was at peace 100% of the time but that would be a lie. God, however, displayed his love and mercy very tangibly and provided a path for us. In my moments of fear and worry, he quickly reminded me of his loving presence, and I would return to a peace that defied logic.

A couple of Scripture verses were especially meaningful to me during this long journey.

"'For my thoughts are not your thoughts, neither are your ways my ways,' declares the Lord. 'As the heavens are higher than the earth, so are my ways higher than your ways and my thoughts than your thoughts'" (Isaiah 55:8-9). I used to struggle with why Karen had this horrible disease. This verse helps me accept that the why is beyond my understanding, at least while I am on this earth.

LONG

"And I pray that you, being
rooted and established
in love, may have power,
together with all
the Lord's holy people,
to grasp how wide and
long and high and deep
is the love of Christ."
Ephesians 3:17-18

"He will wipe every tear from their eyes. There will be no more death or mourning or crying or pain, for the old order of things has passed away" (Revelation 21:4). Karen went home to be with Jesus on April 24, 2016. I am filled with gratitude in the knowledge that Karen is healed and whole and is now fully what God created her to be.

None of us are likely to get through this life without some kind of long, tough journey. As I was finishing this painting, *Long*, I felt a nudge to overlay the long staircase with a cross. I think God wanted me to emphasize that Christ's love is longer than any journey we will have. He will sustain us and guide us; we just have to let go of our own desires and take his hand. I know this is true; I have experienced it. May you experience it as well.

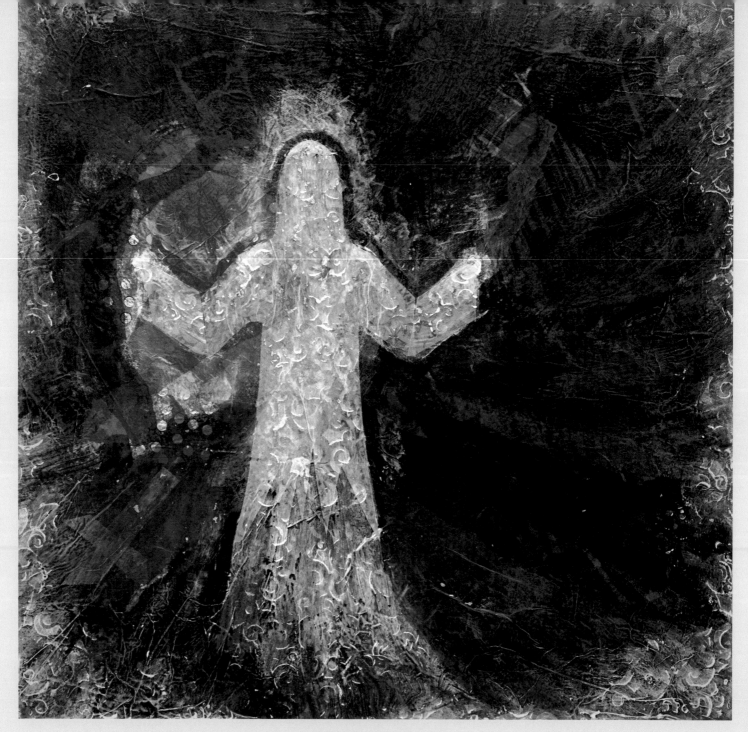

AMAZING GRACE

"He is not here; he has risen, just as he said. Come and see the place where he lay."
Matthew 28:6

LET MERCY TRIUMPH

I was reflecting on God's mercy the other day. It was through his extravagant mercy that he sacrificed his Son to an excruciating death, so I could have eternal life. I don't deserve his mercy, because I don't live a perfect life. In his mercy, God decided his Son would take the punishment for all of my sins so I would not have to endure that punishment.

Ephesians 2:4-5 says, "But because of his great love for us, God, who is rich in mercy, made us alive with Christ even when we were dead in transgressions—it is by grace you have been saved." What a gift! What a blessing!

Jesus was very clear that as recipients of God's mercy we are to show mercy. In the Parable of the Unmerciful Servant (Matthew 18:21-35), Jesus tells of the master who has shown mercy to a servant who subsequently shows no mercy to someone who had wronged him. The master says to the unmerciful servant, "Shouldn't you have had mercy on your fellow servant just as I had on you?" (Matthew 18:33). That is Jesus' question to us.

Why is it that when I am wronged in some way I am often stingy with my mercy? As I reflected on this, it really boils down to two issues.

First, I like to play judge and jury. Can anyone else relate? It doesn't have to be an egregious wrong for me to want to judge. I am particularly fond of playing judge in the pettiest of situations! My inflated sense of justice calls me to declare someone else wrong (which of course makes me right). I want them to acknowledge their wrongdoing, apologize, and perhaps suffer just a little. In my righteous indignation, I totally forget what Jesus said in Matthew 7:1, "Do not judge, or you too will be judged." Jesus takes it further in Matthew 6:14 when he says, "For if you forgive other people when they sin against you, your heavenly Father will also forgive you." Not only am I not to judge, I am to forgive them too.

God is the only one who is fit to judge those who might wrong me. He knows their heart, I don't. He completely understands their circumstances, I don't. I am not God, even though I try to act like I am.

The second issue underlies the judging problem and really is the heart of the matter. When I don't show mercy, I am focused on me. I am not focused on God and his truth. I am not focused on the other person and what they might be feeling or dealing with. When it comes down to it, most of my sin is driven by me focusing on me, me, me.

In this painting, *Amazing Grace,* I wanted to convey God's mercy toward us through the death and resurrection of his Son. My gratitude for these events should profoundly shape my every behavior. James 2:13 says, "Mercy triumphs over judgment." As a Christian, I am called to imitate Christ and sacrifice myself for the other person. I am to sacrifice my self-absorption and my flawed sense of justice, and freely show mercy whenever I am wronged. This is an unnatural act and against all my basic instincts!

How in the world do I accomplish it? I just have to access the power that is already within me. The Holy Spirit is ready and longing to be busy providing wisdom for each situation I face. James 3:17 says, "But the wisdom that comes from heaven is first of all pure; then peace-loving, considerate, submissive, full of mercy and good fruit, impartial and sincere."

Those are adjectives that I would like to have associated with me. I am praying that whenever I am feeling wronged, I will ask the Holy Spirit to help me let mercy triumph.

HORTON OR MAYZIE?

Faithfulness is part of God's character. Psalm 33:4 says, "For the word of the Lord is right and true; He is faithful in all he does." Dictionary.com defines faithful as "1. strict or thorough in the performance of duty; 2. true to one's work, promises, vows, etc.; 3. steady in allegiance or affection; loyal; constant." I think they could have just put in a one-word definition: God!

As Christians, we rely on God's promises and his faithfulness. Lamentations 3:22-24 (NLT) says, "The faithful love of the Lord never ends! His mercies never cease. Great is his faithfulness; his mercies begin afresh each morning. I say to myself, 'The Lord is my inheritance; therefore, I will hope in him!'"

Over the past months as I have been writing weekly devotionals, I have relied on his faithfulness in spades! I never know what he wants me to write from week to week. God wants me to trust in his faithfulness, his provision, and his inspiration on what to write. He has proved reliable and I have experienced God's faithfulness in fresh and profound ways. Along the way I've learned a few lessons about faithfulness.

I've learned that he wants me to be as faithful to him as he is faithful to me. As Christians we are to reflect God's character in our lives. When people observe how I live they should see a glimmer of his faithfulness reflected in me.

What does faithfulness to God look like? God's faithfulness comes out of his love for us. So perhaps for you and me, it is as simple as living out what Jesus said in Matthew 22:37, "Love the Lord your God with all your heart and with all your soul and with all your mind." I hope the vibrant colors of this painting, *Unfailing Love*, convey that loving God with faithfulness requires energy and intention. Genuine love for him is not lazy. God calls us to respond to his love with active worship and purposeful service.

Although the Bible is chock full of examples of faithfulness (Hebrews 11 is like the Faithful Hall of Fame), I thought about Dr. Seuss' book, *Horton Hatches the Egg*. In this book, Mayzie, a fickle and flighty bird, convinces Horton, an elephant, to sit on her egg while she goes on a long vacation. Despite many trials, Horton is faithful to his commitment to Mayzie, often saying, "I meant what I said, and I said what I meant. An elephant's faithful, one hundred percent!"

I am afraid that I often behave a bit more like Mayzie than like Horton. My nature is to be more fickle than faithful. I'm good at giving lip service to loving God with all my heart, soul, and mind. Actually doing that, however, is not my forté. I am easily distracted and sometimes my love and devotion are very fleeting and flighty. I end up loving God with a portion of my heart instead of all of it.

I don't know the secret of Horton's faithfulness, but I have learned the only way for me to be faithful to God is to stay connected to him. I have found that unless I spend time in Bible study and prayer, I cannot hear that whisper of inspiration. He is always there faithfully waiting for me with exactly what is needed. God is waiting for me to love him enough to seek him.

Galatians 5:22-23 tells me, "But the fruit of the Spirit is love, joy, peace, forbearance, kindness, goodness, faithfulness, gentleness and self-control." I am incapable of bearing this fruit through my own will power. But with the help of the Holy Spirit I can begin to overcome my Mayzie-like tendencies.

At the end of our days, don't we all want to hear, "Well done, good and faithful servant" (Matthew 25:21)? I'm praying for the Holy Spirit's help in being more Horton-like in my devotion to God—faithful, one hundred percent! How about you?

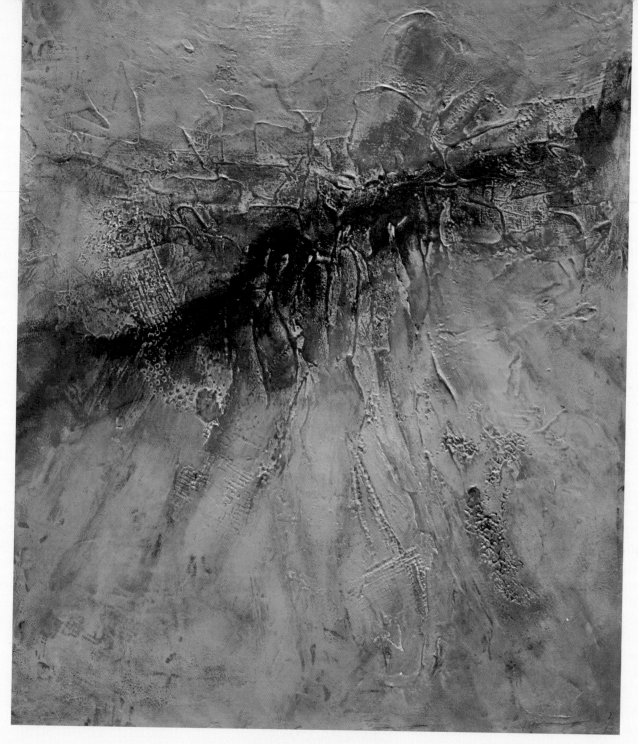

UNFAILING LOVE

"The faithful love of the Lord never ends." Lamentations 3:22 (NLT)

FOCAL POINT

"And let us run with perseverance the race marked out for us,
fixing our eyes on Jesus, the pioneer and perfecter of faith." Hebrews 12:1b-2a.

STOP, LOOK, AND LISTEN

"Love the Lord your God with all your heart and with all your soul and with all your mind" (Matthew 22:37). After writing my last devotional about being 100% faithful to God, I spent some time thinking about how one actually achieves that. I first took stock of my current situation. How much of my time do I spend actually loving God with all my heart, all my soul, and all my mind?

Surely my quiet time with God in the mornings can qualify. I've gotten a little better about spending daily quiet time with God in recent years, so I probably average about thirty minutes a day if I throw in the time I spend preparing for my weekly Bible study group (and I don't subtract the time my mind wanders all over the place!). I did the math on this and assuming I am awake sixteen hours a day, this come to a whopping three percent of my time. So, let's add in weekly worship, women's Bible study, and the periodic project to serve others, and I might be able to add an average of three and a half hours per week. That moves me up to six percent. Even if I add the occasional pop-up prayers that I utter, I think I would be hard pressed to get to eight percent. That is a long, long way from 100%!

Now when I am having an absolutely terrible day, I may spend a bit more time desperately pleading for help from above. Conversely, when I have an absolutely fabulous day, I may spend more time praising him. However, the vast majority of my life's time is spent on the ordinary and mundane. On those kinds of days, if I really love God like I say I do, you would think my heart's desire, my soul's longing, and my mind's discipline would compel me to spend more time in communion with him. Deep down I don't want Christ's words to the church in Ephesus to apply to me, "Nevertheless I have this against you, that you have left your first love." (Revelation 2:4, NKJV).

So how do I move beyond the six to eight percent level (which hardly screams, "I love God with all my heart, soul and mind")? Possible answers came to me in the form of a bunch of "What Ifs" to share with you.

- What if my heart's desire and my soul's longing and my mind's discipline moved me to seek him in my ordinary moments?
- What if I used the old safety motto, "Stop, Look, and Listen" as a device to keep me on track?
- What if I paused several times a day, in the midst of the ordinary, to look for him in that moment? God is always there but I won't experience him unless I discipline my mind to pause long enough to seek him.
- What if I looked for what God was doing in my life at that moment? Is there something in this mundane moment to thank him for? Is there an opportunity to serve someone else in his name?
- What if I listened to his voice as I paused? Maybe he wants to reassure me of his unfailing love for me. Maybe God wants for me to let go of my "plan" for the day and follow his better plan.
- What if I stopped, looked, and listened multiple times a day?
- What if I stopped robbing myself of the time he'd love to spend with me?

Why not let God infuse my life with multiple doses of his truth and wisdom, his love and encouragement, and his kindness and compassion? I wonder how many more opportunities God would have to bless me and bless others through me.

The cross in this painting embodies the title, *Focal Point*. Even though there are other interesting colors and patterns to view, that cross immediately captures your attention. I think I'll use this painting to remind me of a few truths. It will remind me to focus on loving God with all my heart, soul, and mind. Secondly, it will remind me to not let my focus wander to other "colors and patterns" of this world that tend to draw my attention away from him. And because my wandering is inevitable, *Focal Point* reminds me to continually refocus and to stop, look, and listen for him in more and more of my life's moments.

I'm not going to worry about percentages, I just want God to see growing evidence that I do indeed love him with more and more of my heart, soul, and mind!

I'll close with one word that means "so be it" or "let it be so"—Amen!

JOYFUL PERSEVERANCE

The brother of Jesus, James, starts out his letter to first century Christians (and us) by telling his readers to rejoice in their trials. He says, "Consider it pure joy, my brothers and sisters, whenever you face trials of many kinds, because you know that the testing of your faith produces perseverance. Let perseverance finish its work so that you may be mature and complete, not lacking anything" (James 1:2-4).

I like the idea of being mature and complete in my faith, but I am not all that fond of going through trials of any kind. As I studied this verse, I discovered James gives us a few steps to move us to the point of considering it "pure joy" when those inevitable problems come our way.

My first reaction when a trial or problem comes my way is to intensely desire for it to just go away—poof—disappear! I have learned, however, that wishing the problem away is highly ineffective. Ignoring the problem doesn't work either (just in case you have tried that approach). Did you notice James uses the phrase "face trials"? That is our first step—we face our trials head on. We don't run away or try to avoid them.

I've tried praying for God to remove problems from my life, however, in most cases God has known that his best plan for me is to face them. The good news is we don't face them alone. Romans 8:35, 37 tells us, "Who shall separate us from the love of Christ? Shall trouble or hardship or persecution or famine or nakedness or danger or sword? No, in all these things we are more than conquerors through him who loved us." What a comfort it is to know that whatever the trial, he is facing it with me.

James second step is in the phrase "testing of your faith." I think James is talking about clinging tenaciously to our faith when times are hard. The kind of clinging James is talking about is not motionless, handwringing, wishful thinking. Clinging requires action. It may mean purposefully reading Scriptures to bolster our faith. I find that reading the Psalms is a tremendous source of strength for me. It may be reaching out to a faithful friend who has been through something similar. It may be remembering how God has seen us through previous problems. For all of us, it will likely involve spending a great deal of time pouring out our hearts to God in prayer.

Step three is where we begin to see some results. Facing our trials and clinging steadily to our faith develops perseverance. The dictionary says perseverance is "steady persistence in a course of action or purpose, especially in spite of difficulties, obstacles, or discouragement." Perseverance is a sign of strength. We build spiritual muscles as we go through trials. I think that's why God allows us to go through them. He doesn't want us to be spiritual wimps! He wants us to be spiritually strong, mature, and prepared for the next trial. In John 16:33 Jesus said, "I have told you these things, so that in me you may have peace. In this world you will have trouble. But take heart! I have overcome the world."

If I can get to the point where I joyfully accept the trials that come my way and experience his peace while persevering through them, I would be what James would call "mature and complete." Let me be candid and tell you that I am not there yet!

I chose this painting, *Persevere*, to accompany this devotion because I experienced some trials in painting it. Many techniques I tried just made it look uglier and uglier. One lesson I have learned in painting is not to give up on a painting, just persevere. Sound familiar? Finally, it began to come together. I like to think my painting became mature and complete!

Perseverance, looks like it has seen some hard times and it's a little rough around the edges, but these qualities give it character. You'll see some gold and copper metallic colors that symbolize the strength that comes from being hammered into shape or purified by fire. There's beauty in character and strength.

Our character, strength, and beauty come from joyfully persevering through whatever trials come our way. We can't do it on our own, even though we often try. The good news is he is faithful to walk with us every step of the way, providing us with his joy, his peace, and his strength. Thanks be to God!

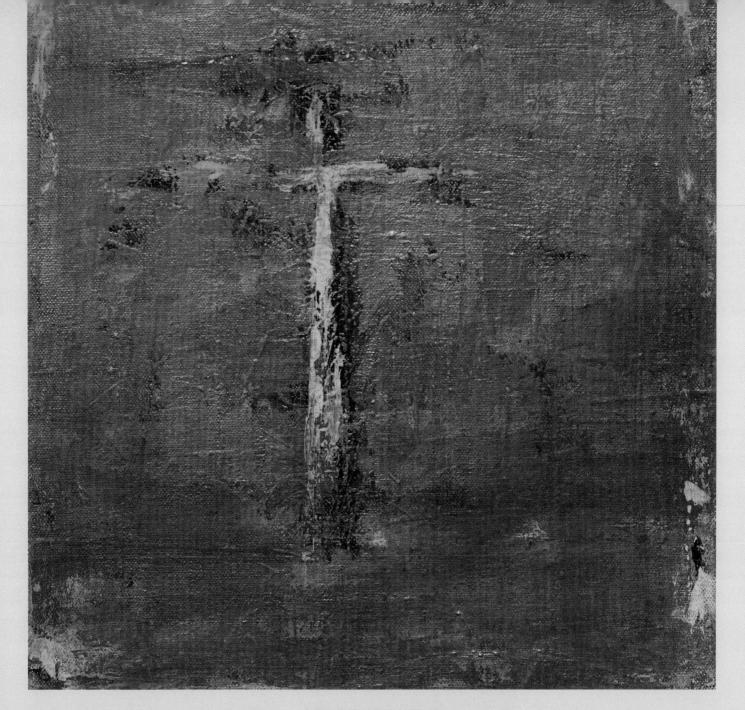

PERSEVERANCE

"Consider it pure joy, my brothers and sisters, whenever you face trials of many kinds, because you know that the testing of your faith produces perseverance. Let perseverance finish its work so that you may be mature and complete, not lacking anything." James 1:2-4

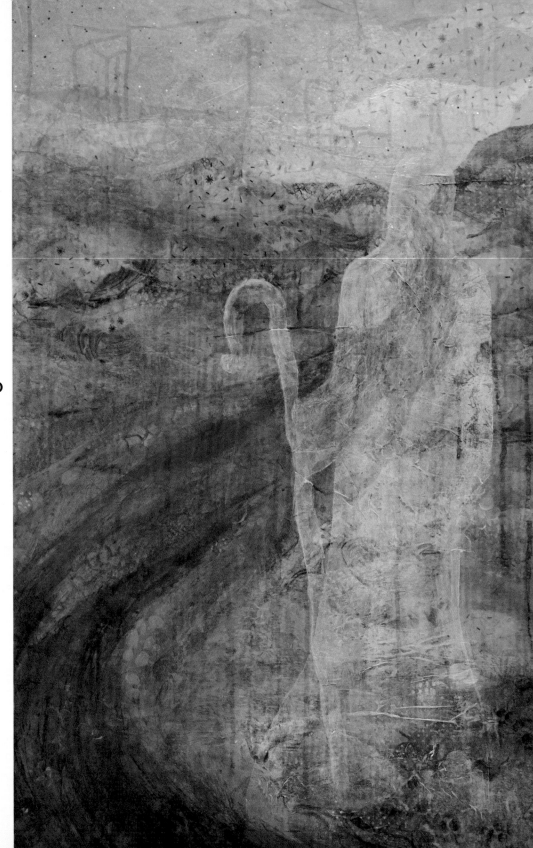

THE GOOD SHEPHERD

"The Lord is my shepherd,
I lack nothing."
Psalm 23:1

TENDER CARE

In the warm months (we have quite a few of those in Houston, TX) I exercise in my pool early in the morning. I use this quiet time to pray and meditate as well as exercise. A few mornings ago, a soft breeze came up and I could see a few leaves begin to flutter and heard a whisper from my wind chimes. It started me thinking about how gently and tenderly God loves us.

In both the Old and New Testaments, we are given the image of both God and Jesus as our Shepherd. Recently my church asked me to create a painting to accompany a sermon series on Psalm 23, one of the most beloved chapters in the Bible. I love the imagery in this Psalm as it paints a picture of our Shepherd God tenderly caring for us. It was a challenge to mirror that gentle imagery in the painting, but more about that later.

Verses 2 and 3 of this beautiful poem say, "He makes me lie down in green pastures, he leads me beside quiet waters, he refreshes my soul. He guides me along the right paths for his name's sake." God knows our every need and desires to tend to those needs. He knows when we need to rest in him, finding nourishment for our hearts and minds. He draws us to still, quiet waters with him, where He will quench our thirst with life-giving water. God will gently and tenderly refresh our souls. He guides us along the path he knows is best for us.

God offers this tender care to us with great love but doesn't force his care upon us. In Matthew 11:29, Jesus makes the same offer to us, "Take my yoke upon you and learn from me, for I am gentle and humble in heart, and you will find rest for your souls." In 1 Peter 5:7 this message is reinforced: "Cast all your anxiety on him because he cares for you."

God offered his tender care to me as I worked on this painting. I had painted the pastoral scene depicted in the Psalm but somehow the painting seemed incomplete. The Holy Spirit nudged me to add our Good Shepherd despite the fact that I was convinced I couldn't paint a shepherd. In his profoundly mysterious and loving way he guided my hands and the image of a shepherd appeared.

What a blessing to have such tender love and care available to us always. But if I stop right here as only a recipient of his love and care, I haven't captured the whole truth of Psalm 23. Verse 3 ends with "for his name's sake." While we benefit from his tender care, his care has a larger purpose—for God to be glorified. We glorify God when, in his name, we show tender care to the others in our lives.

Paul tells us in Galatians 5:23 that gentleness is one of the facets of the fruit of the spirit. In Ephesians 4:2 he says, "Be completely humble and gentle; be patient, bearing with one another in love." That sounds an awful lot like the Shepherd in Psalm 23. I think Jesus' last instructions to Peter in John 21:15-17 give us clear direction. Jesus tells Peter to feed his lambs, take care of my sheep, and feed my sheep. These are our instructions as well.

God places people in our lives so we will share with them the tender care he has given us. Doing this with some is really easy. I have found, however, that some to whom he wants me to show tenderness and gentleness are not as lovable as I would like, and I need his Spirit to empower me. If I just ask, he will gently remind me that it's all for his glory. His Spirit will tenderly provide nourishment for my soul and guide me in the path he has for me—all for his name's sake. He will do the same for you.

PROCLAIM

People sometimes ask me how I decide what to write about. The short answer is that the Holy Spirit provides the ideas. This is a kind of mysterious process where an idea comes into my head but somehow, I recognize it as not my own. Sounds kind of goofy, unless you have experienced it!

This week, the idea of writing about proclaiming the gospel popped into my head. It was one of those ideas I thought could not possibly be my own. I would never voluntarily write about proclaiming. I have never been a good proclaimer of the gospel. I do fine in an environment of fellow Christians. However, when in the company of people whose beliefs are unknown to me, I tend to be quite timid and, well, mostly silent about things of faith. So when the Holy Spirit nudged me to write about proclaiming, I was hoping I hadn't heard right. Wouldn't you know that the next day in my devotional readings there were not one, but two references to proclaiming. So here goes!

The Bible has quite a bit to say about proclaiming. The Psalms frequently advocate proclaiming what God has done. Psalm 35:28 says, "My tongue will proclaim your righteousness, your praises all day long." Psalm 71:16 tells us, "I will come and proclaim your mighty acts, Sovereign Lord." Being a somewhat reluctant proclaimer, I could interpret these as suggestions or good ideas. However, Psalm 105:1 presents something that looks a whole lot more like a command, "Give praise to the Lord, proclaim his name; make known among the nations what he has done."

Let's see what Jesus says about proclaiming. In Matthew 10:27 Jesus said, "What I tell you in the dark, speak in the daylight; what is whispered in your ear, proclaim from the roofs." We get some more insight from Luke 9:60: "Jesus said to him, 'Let the dead bury their own dead, but you go and proclaim the kingdom of God.'" These statements seem pretty straight-forward. We are to proclaim, we are to speak, we are to share the good news of Jesus Christ with others. Just to be sure, I looked again at the Great Commission in Matthew 28 where Jesus commanded (not suggested) that we go and make disciples by teaching them. While Jesus doesn't use the word proclaim in this case, I don't think there is a way to teach and make disciples without using words in some way!

For those of us who are reluctant proclaimers, we like to think that those with the gift of preaching and teaching are really the ones who are called to proclaim. Some of us fall back on the old adage that actions speak louder than words. We delude ourselves into thinking that the recipient of our good deed will instinctively know about Jesus. What I glean from the Scriptures above is that we have to use words to proclaim. It is unavoidable!

I think the Holy Spirit has been trying to teach me that proclaiming happens any time we use our words to share how Jesus has made a difference in our lives. 1 John 1:3 makes it simple: "We proclaim to you what we have seen and heard." That's our call, to share what we have seen and heard. In reality there is nothing more powerful than our own stories of how we have experienced God's grace and love. A couple of weeks ago, my husband went to visit a life-long friend who was terminally ill. He spoke to this friend about what it meant to be a Christian—he simply shared what he had experienced and knew to be true. Our friend accepted Jesus as his Savior that day. As a result, when this friend died two days later, amid the tears, we could rejoice with his family in the knowledge that he was spending eternity with Jesus.

My proclaiming isn't going to necessarily look like my husband's proclaiming. I hope these devotionals are one way God has called me to proclaim. I know he also desires for me to be braver and bolder about sharing my faith in my personal interactions with others. That's why this painting, *Proclaim*, is in such bold colors! It is certainly not my favorite painting but perhaps those bright colors will inspire me to boldness and remind me that proclaiming is not optional. Jesus told us to do it. The good news is that God has unique plans for each of us to speak and proclaim the gospel. Through the power of the Holy Spirit, he will equip us to do it. We just need willing hearts. As Matthew 12:34 says, "For the mouth speaks what the heart is full of." Amen (let it be so)!

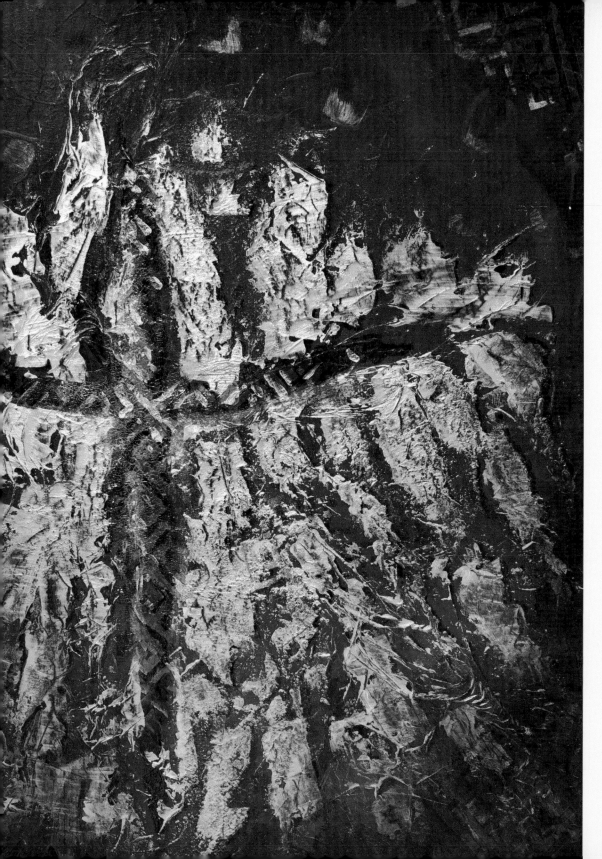

PROCLAIM

"What I tell you
in the dark,
speak in
the daylight;
what is whispered
in your ear,
proclaim from
the roofs."
Matthew 10:27

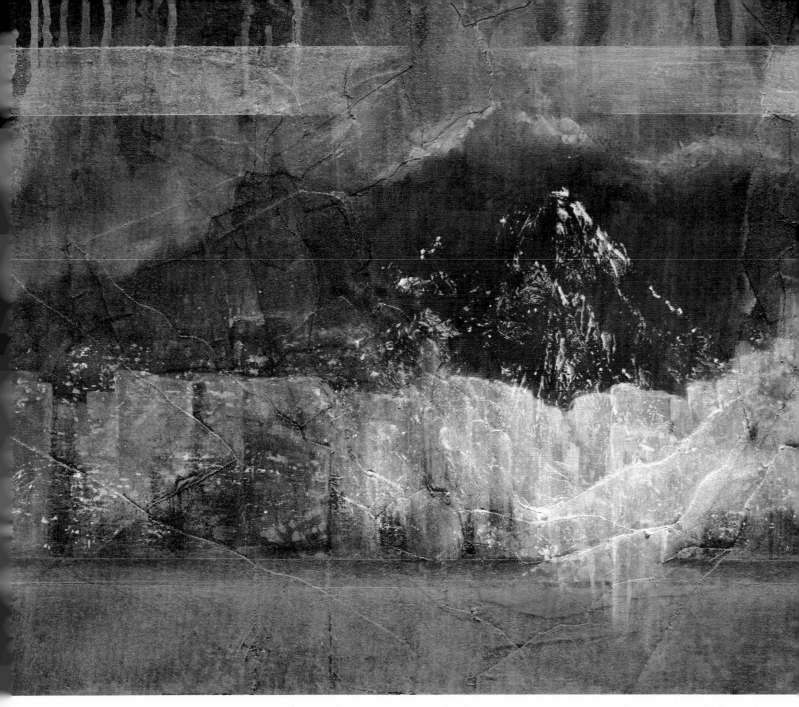

ALMIGHTY

"Who is like you, Lord God Almighty?
You, Lord, are mighty, and your faithfulness surrounds you." Psalm 89:8

MIGHTY YET TENDER

I have a hard time getting my brain around the dual reality of our God's "Almightiness" and his deep and intimate love for me as an individual. My rational self just has trouble with this juxtaposition. How in the world can the all-powerful God who created and ordered all of creation have the time to be interested in me? How can he have that same interest and love for billions of us while still sustaining everything we can see as well as the things we can't see? My brain is way too limited to grasp this reality.

Biblical references to God's might are numerous in the Bible. Here is a sampling:

- "The Mighty One, God, the Lord, speaks and summons the earth from the rising of the sun to where it sets" (Psalm 50:1).
- "Who is like you, Lord God Almighty? You, Lord, are mighty, and your faithfulness surrounds you" (Psalm 89:8).
- "No one is like you, Lord; you are great, and your name is mighty in power" (Jeremiah 10:6).

In Isaiah 9:6 the prophet, Isaiah, promises us that God's might and power will be embodied in the Messiah, "For to us a child is born, to us a son is given, and the government will be on his shoulders. And he will be called Wonderful Counselor, Mighty God, Everlasting Father, Prince of Peace."

The Bible is equally generous in references to God's tender side where we read of his intimate love and care for each of us. The Old Testament is full of references to his unfailing and enduring love. In Psalm 139, David acknowledges God's intimate knowledge of him and his constant presence with him. In verse 6 David says, "Such knowledge is too wonderful for me, too lofty for me to attain." I can relate to David!

In both the Old and New Testament, God's tender care is described as shelter under his wing. Psalm 63:7 says "Because you are my help, I sing in the shadow of your wings." Jesus speaks of his desire to show his tender love for us in Matthew 23:37, "how often I have longed to gather your children together, as a hen gathers her chicks under her wings." This picture of his love for us is beautifully tender.

God's greatest demonstration of his tenderness and love is, of course, the provision of his Son, our Savior.

I will never be able to fully comprehend how and why the all-powerful and mighty Creator wants to know me and love me in the most intimate and complete way possible. Despite that, I know God wants me to enjoy this wonderful gift in faith. He also desires for me to mirror these characteristics to others.

He wants us to be mighty: mighty in our faith and mighty in our devotion to him. Our own might is pretty weak. At least, mine is. Only he, through the power of the Holy Spirit, can provide me the might he calls me to exhibit. Ephesians 6:10 says, "Finally, be strong in the Lord and in his mighty power."

He also wants us to mimic his tenderness in our dealings with others. The apostle Paul gives us a picture in Philippians 2:1-3, "Therefore if you have any encouragement from being united with Christ, if any comfort from his love, if any common sharing in the Spirit, if any tenderness and compassion, then make my joy complete by being like-minded, having the same love, being one in spirit and of one mind. Do nothing out of selfish ambition or vain conceit. Rather, in humility value others above yourselves."

Just as it is hard for me to comprehend these equally significant aspects of God's character, I had a hard time creating a painting that would do justice to both "mighty" and "tender". After many, many layers of paint and fabric, I finally concluded that God wanted this painting to portray his might. I'm sure he'll provide a painting for his tender side one of these days!

Regardless of my painting difficulties, our calling is still a dual one—to be mighty and tender just as he is mighty and tender. Right now, I'm not sure anyone would use those adjectives to describe me. It is not an easy task for any of us. But it is possible through his mighty power at work in us. Thanks be to God!

DANCING FOR JOY

I wrote a devotional on joy just a few weeks ago, but for some reason the Holy Spirit decided that I needed to write another one. Perhaps it is because we often miss out on the joy God wants us to experience. God's desire is for us to be filled with joy, his joy, all the time.

The concept of 24/7 joy seems to be a lofty aspiration. It is our destiny and will be our reality in Heaven. Here on Earth, however, it often seems elusive; but I think there is more joy available to us than we actually access.

I have found my problem (and perhaps yours?) is that I seek joy in circumstances and in outcomes. The truth is that joy doesn't reside in circumstances or outcomes. Joy is a God thing. He is the creator and essence of joy. I have found deep, profound, and abiding joy is a byproduct of my relationship with him. Psalm 16:11 says, "You will fill me with joy in your presence, with eternal pleasures at your right hand." He is our richest blessing and our deepest joy.

Ironically, obedience, a word that stirs up in me a very unholy sense of rebellion, is one behavior that offers a big dose of joy. When I first felt God's call to write these devotionals and post them on a website, my first response was "I don't know how to do that." However, uncharacteristically, I quickly moved to obedience. In that moment I had one of the most profound senses of joy I have ever experienced.

Psalm 19:8 tells us, "The precepts of the Lord are right, giving joy to the heart. The commands of the Lord are radiant, giving light to the eyes." In obedience to him, we acknowledge (consciously or unconsciously) several things that are key to our joy in him:

- He loves us and knows what is best for us.
- We trust him because of his love.
- He is in control and we are not.
- He has a plan that is better than our own plans.
- At the end of the day, we will be with him and experience 24/7 joy forever!

When we obey, we are walking with God along the path that he has created uniquely for us. (I love the mental picture—maybe I'll have to try and paint that.)

After I finished the tree in this painting, I thought the tree looked like it was about to bust into a dance move out of sheer joy. So I named the painting *Dancing for Joy*. The verse that accompanies this painting is: "You turned my wailing into dancing; you removed my sackcloth and clothed me with joy" (Psalm 30:11). God longs for us to find that joy in him. Joy comes when we know him so well and trust him so much, that we respond in obedience to his will for us.

Sometimes we may think God saves joy for the big acts of obedience. In reality, he offers me multiple opportunities to obey him each day, but I must be willing to look for them. The joy found in obedience won't always move you to elation or to burst into spontaneous dancing, but if it does, go for it! I have found that joy is sometimes a deep, profound sense of peace and well-being that has nothing to do with what is going on around me. It is a quieter joy, but it is still joy.

I need the Holy Spirit to remind my rebellious spirit of the joy waiting for me if I simply respond in obedience to him. I pray all of us will open our eyes to his opportunities for joy each and every day and respond in obedience. Joy awaits!

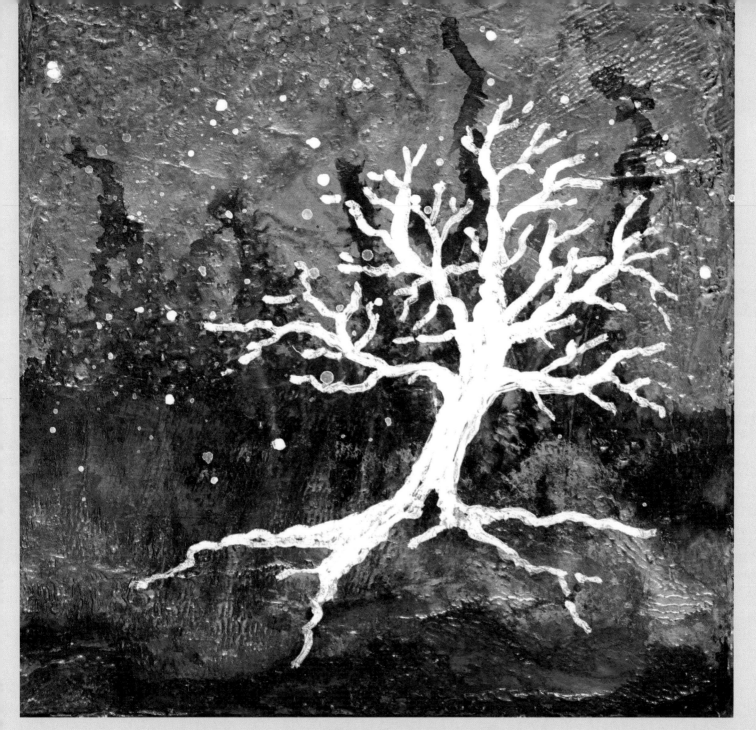

DANCING FOR JOY

"You turned my wailing into dancing;
you removed my sackcloth and clothed me with joy." Psalm 30:11

AT MY RIGHT HAND

"I keep my eyes
on the Lord.
With him at my
right hand,
I will not
be shaken."
Psalm 16:8

POSSIBLE BUT NOT ALWAYS EASY

"What is impossible with man is possible with God" (Luke 18:27).

Many of us take comfort from these words of Jesus. When God calls us to a challenging task, it is very comforting to know he can make it possible. I often leap to the assumption that if he calls me to do something, then he will make it quick and easy, smooth sailing, no storm clouds, no rough seas, no delays. Hmmm—not so much!

When we respond to his call in obedience, God will make the realization of that call possible. The road to possible, however, is often long and rough and sometimes dangerous. Sometimes the difficulties are of our own making and sometimes they are just part of living in a broken world.

God called David to be king of Israel. The road from shepherd to king was long and difficult. David had to deal with an intimidating giant and a mentally deranged incumbent along the way (read chapters 16-31 in 1 Samuel for details). The Psalms are full of David's cries to God for protection and wisdom to deal with the difficulties. In his perfect timing, God brought to fruition what he had promised to David.

God called Abraham to move from his homeland to be the father of a chosen people when Abe and Sarah had no children. While Abraham moved his family in obedience, he and Sarah became impatient with God's timing in delivering the heir that he had promised them. They took matters into their own hands (Genesis 16) and their actions resulted in a long series of painful consequences that are still being played out in the Middle East. Yet God was faithful, and the promised child came when Abraham was 100 years old. The challenges continued for Abraham when God asked him to sacrifice his treasured son, Isaac. I can't imagine how difficult it must have been for Abraham to respond in obedience to God, but his faith prevailed. He told Isaac, "God himself will provide the lamb." (Genesis 22:8). Despite his long and difficult journey, God made possible what he had promised to Abraham.

Painting is hard for me, yet God has called me to do it. I pray before I begin to paint asking God to guide me and for the painting to glorify him. My problem is that as I begin to paint, I begin to rely on my own inadequate skills and forget to include his helper, the Holy Spirit, in the process. Once I have a big, ugly mess on the canvas, I realize I have forgotten to stay in step with him. Instead of my focus being on him, it is on my own ideas and plans for the painting. I can't tell you how many times this has happened. I know better, but I slip back into that behavior at the drop of a hat (or paintbrush!).

This painting (*At My Right Hand*) is an example. I worked on the painting for quite some time and thought it was progressing nicely, so I took a break. During that break I thought about how much I needed him in my process of painting. When I returned to the painting, I decided it needed some tweaks. I proceeded to tweak (with no thought of consulting my Helper) until it was a total mess.

The apostle Paul gives us the wisdom we need as God calls us to tasks that seem impossible. In Galatians 5:25 he tells us, "Since we live by the Spirit, let us keep in step with the Spirit." And in 1 Thessalonians 5:17 he instructs us to "pray continually." God will make the seemingly impossible possible if we will stay connected to him. Not just at the start of the journey, but at every step along the way. In Ephesians 3:20, Paul explains that through God's power at work in us, he can do immeasurably more than we ask or imagine.

By the way, after praying fervently and keeping my focus on his plans for this piece, God was faithful to guide me to the painting he had in mind. Not surprisingly the verse that goes with this painting is "I keep my eyes the Lord. With him at my right hand, I will not be shaken" (Psalm 16:8).

BREATH OF HEAVEN

"All Scripture is God-breathed and is useful for teaching, rebuking, correcting and training in righteousness" (2 Timothy 3:16).

I have always loved the way Paul expresses the nature of Scripture in the verse above—God breathed. If we think about it, God uses his breath to accomplish many things. He brought life to mankind through his breath. Genesis 2:7 says, "Then the Lord God formed a man from the dust of the ground and breathed into his nostrils the breath of life, and the man became a living being." In Job 33:4 we are reminded, "The Spirit of God has made me; the breath of the Almighty gives me life."

How on earth does one begin to represent the breath of God? Frankly it is impossible, but my hope is that in this painting the wispy shapes suggesting movement will remind us of the beauty and vitality God breathes into all of his creation through the gift of his Son.

God's breath sustains all of life on earth—both physical and spiritual. That makes his breath pretty essential to my well-being. Paul told Timothy that Scripture was useful. At that point the New Testament was not yet in existence but perhaps once that was accomplished, dare I suggest Scripture was upgraded from useful to essential?

For much of my life I've thought the usefulness of Scripture was deployed when someone used it to train, rebuke, correct, and train me. Or conversely, when I used it to teach, rebuke, correct, and train someone else. I think both are absolutely ways God wants us to use his God-breathed words. But I've learned God wants us to use Scripture in a deeply personal way.

I've begun to experience how God uses his Word with me one-on-one. As I read and study his Word, he teaches me about who he is and his never-ending love for me. He rebukes me when I am pig-headed and have wandered off on my own path instead of following his. He gently corrects me when my thinking gets skewed by the culture that surrounds me. He trains me to trust him in the biggest event and the smallest detail.

I have come to a deepening awareness that spending time reading and studying those God-breathed words is life giving. I cannot be spiritually healthy and vibrant if I am not getting my spiritual breath from him. Physically, if I don't breathe and get enough oxygen, I am not going to last long. I cannot count the number of times I have been spiritually asphyxiated because I don't spend time in God's Word. Why do I do that? I need it so badly! I'm robbing myself of the nurture and training I need. Proverbs 12:1 puts it pretty bluntly, "Whoever loves discipline loves knowledge, but whoever hates correction is stupid."

Stupid is a strong word, but I'm afraid the "shoe fits" me far too often. I do best when I participate in a structured Bible study. The accountability and the fellowship help me commit to regularly getting into his Word. For the last couple of years, the call to write devotionals regularly provides an ongoing nudge to let him breathe his Word into me. Without some kind of structure, my self-discipline is very wobbly, and I let other activities push this vital, life-giving experience to the back burner. (If you have the same problem, find a Bible study or start one in your neighborhood. There are resources galore!)

What I have found is that in his Word, God has so much more for me than training, rebuking, correcting, and teaching. Through his God-breathed words, he fills my heart with all kinds of gifts. I find hope and peace and joy and gratitude. God is our spiritual oxygen. Through his Word he gives us life—abundant life. Let's resolve to not wander around asphyxiated!

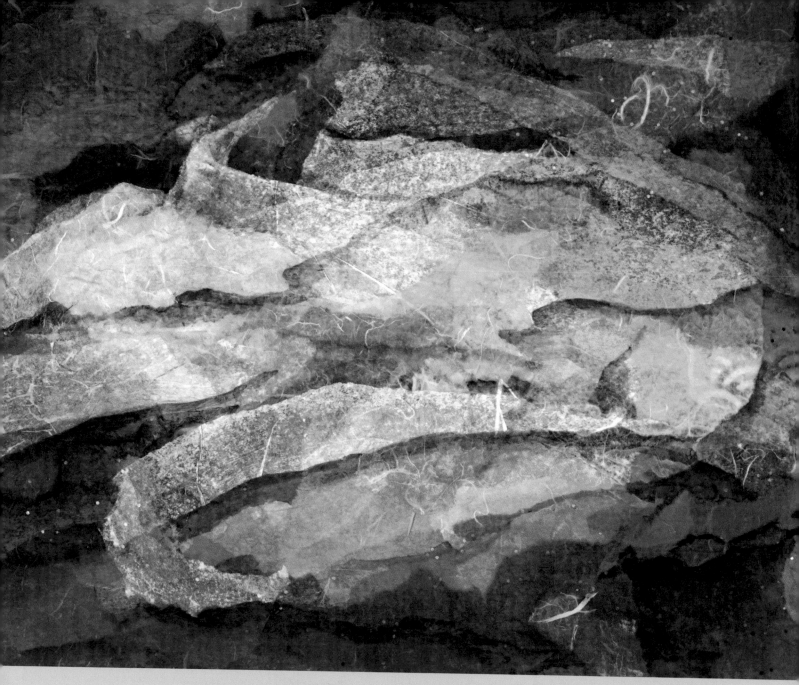

BREATH OF HEAVEN

"All Scripture is God-breathed and is useful for teaching, rebuking, correcting and training in righteousness." 2 Timothy 3:16

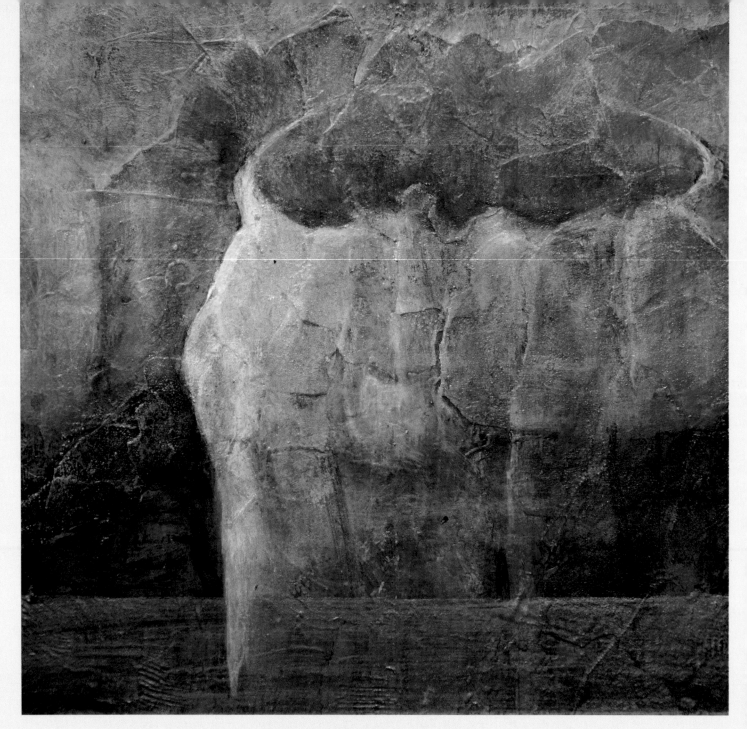

JAR OF CLAY

"But we have this treasure in jars of clay to show that this
all-surpassing power is from God and not from us." 2 Corinthians 4:7

HOW TO FIX A CLAY JAR

*T*his week I was feeling discouraged about a painting. Everything I was trying to do felt like an uphill struggle with little progress made. In the midst of it, I still knew God had a purpose and a plan for the painting. So I kept working. Sure enough, an image began to emerge on the canvas—unplanned and unexpected. The image was that of a jar, a piece of pottery. A familiar Bible verse popped into my head, "But we have this treasure in jars of clay to show that this all-surpassing power is from God and not from us" (2 Corinthians 4:7). I sensed that the Holy Spirit was showing me what I was to write about this week!

Clay jars or pots are fragile things. They get chipped and cracked easily. If you drop one, you can expect it to shatter into many pieces. We are just like those jars. When we bump up against life's rough times, we chip and sometimes crack. When we experience circumstances where the bottom drops out and we are in deeper and darker places than we ever imagined, we feel broken and shattered and don't know how to pick up the pieces.

In the verse above, the apostle Paul tells us we have a treasure within. Paul defined that treasure in 2 Corinthians 4:6: "For God . . . made his light shine in our hearts to give us the light of the knowledge of God's glory displayed in the face of Christ." In other words, we have Christ in us through his Holy Spirit. Only through his power and strength can we clay jars begin to show his light to the world around us. Paul also reminds us we have to remain humbly aware that any strength and power we have comes from above. This clay jar gets plenty of reminders of how little I can accomplish in my own power (especially when it comes to painting).

It is through the Holy Spirit that we have the strength and power to patch those chipped places, mend the cracks and put the pieces back in place. Paul prayed for the Ephesians, "that out of his glorious riches he may strengthen you with power through his Spirit in your inner being" (Ephesians 3:16). The Holy Spirit can also fill our jar with his fruit: "the fruit of the Spirit is love, joy, peace, forbearance, kindness, goodness, faithfulness, gentleness and self-control. Against such things there is no law" (Galatians 5:22-23). The Holy Spirit is always available to mend and fill me. All too often I try to do my own jar repair and use my own willpower to be kind, good, faithful, etc.

It is only when we invite the Spirit to fill our jar of clay that we begin to mend, and the light of our Savior begins to make us glow with his love, joy, peace, patience, kindness, goodness, faithfulness, gentleness, and self-control. Our rough edges may still be slightly visible, and a few cracks might still be there; but I think that's part of the beauty of our clay jars. Those around us can see we are authentic and haven't had charmed lives by being Christian. Hopefully what they see is that Jesus, through his Spirit, can take any broken jar and make it glow with his light. Paul says it beautifully in Philippians 2:15-16, "Then you will shine among them like stars in the sky as you hold firmly to the word of life." Lastly, Paul has a promise for us in Ephesians 3:20. He tells us that God, "is able to do immeasurably more than all we ask or imagine, according to his power that is at work within us." Let's shine like the stars this week—through his power!

GOD'S INTENTIONS

I'm going to start out on a very cheerful note: bad things happen to us as we go through life. Sometimes the "badness" befalls us simply because we live in a broken world where disease, death, disasters, and tragedies are all too common. Sometimes our tough times are the consequences of our bad choices. 1 Peter 5:8 says, "Your enemy the devil prowls around like a roaring lion looking for someone to devour." Sometimes we aren't the ones devoured, but our lives are negatively impacted by someone else who has been devoured by evil.

Hard times are something we all have in common and mankind has been trying to make sense of them for eons. What we know and can be assured of is this: in the midst of the bad times, God is working things out for his purposes which is our ultimate good. His motivation is simple—love. Unlike most of us humans, he has no ulterior motives.

A very familiar verse (Romans 8:28) reassures us of his intentions: "And we know that in all things God works for the good of those who love him, who have been called according to his purpose." Jeremiah 29:11 reinforces his message, "'For I know the plans I have for you,' declares the Lord, 'plans to prosper you and not to harm you, plans to give you hope and a future.'"

The story of Joseph in Genesis is a great example of God's intentions overpowering people or circumstances that cause harm. Joseph's brothers sold him into slavery in Egypt. It was probably very hard for him not to have a gigantic pity party over the next few years as he endured slavery, an unjust trial, and imprisonment. God ultimately put him in a position of power in Egypt where he prospered. Years later, when reunited with the brothers who sold him into slavery, he told them, "Even though you intended to harm me, God intended it only for good, and through me, He preserved the lives of countless people, as He is still doing today" (Genesis 50:20, The Voice).

Recently, Acts 24 was the focus of discussion in a Sunday School class I attend. Much to my surprise, there I found another wonderful example of God's good intentions. In this chapter of Acts, Paul has been falsely accused of stirring up riots and Felix, the Roman Governor of Judea, was presiding over his trial. Felix was basically a corrupt guy with no guts. He didn't want to make a controversial decision, so Paul sat in jail for two years. What I learned from our class discussion was that God had significant plans for Paul during those two years. It is likely that during his time in prison, Paul wrote letters to the churches he had started on his missionary journeys. His companion, Luke, probably wrote the Gospel of Luke as well as Acts during this time. Had it not been for this unjust two-year prison stint, our New Testament would have a giant hole in it.

Paul wrote the letter to the Romans before this imprisonment and I suspect the truth of what he wrote in Romans 8:28 was ever-present with him. One of the letters he wrote during those prison years was Philippians—known as the joy letter. In this short letter, Paul refers to joy or rejoicing sixteen times. Paul knew God was using what had been intended to do him harm for his good purposes. Paul probably had no idea his letters were going to make up a huge chunk of our New Testament, but he was totally confident God was working for good.

When (not if) hard times come our way, we, like Paul, can be 100% sure God's intentions for us are good. While we may not be able to discern God's intentions yet, it is still possible to experience joy. We can grow and thrive in our faith like the tree in this painting, *Flourish*, because we are secure in the knowledge that God's intentions for us are always good because he is always good!

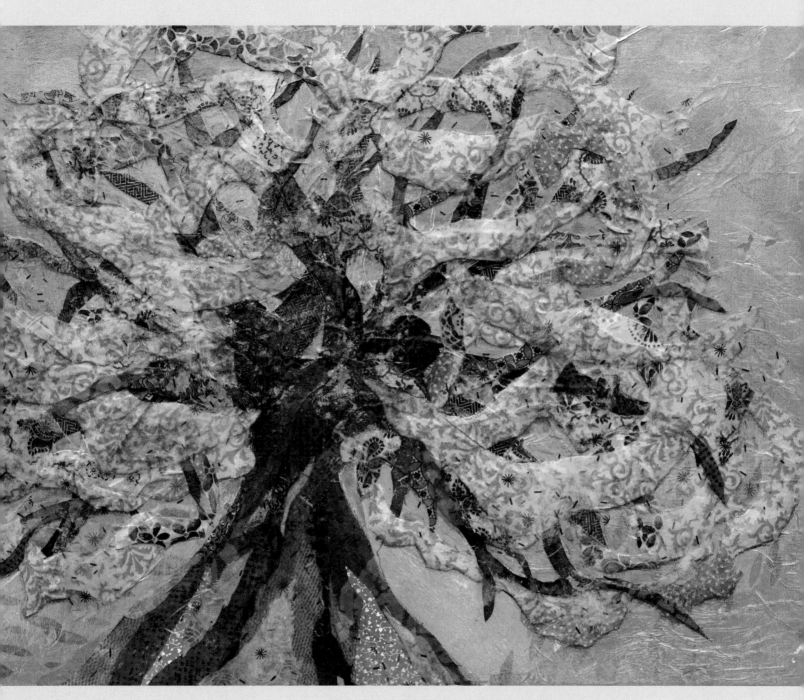

FLOURISH

"But I am like an olive tree flourishing in the house of God;
I trust in God's unfailing love for ever and ever." Psalm 52:8

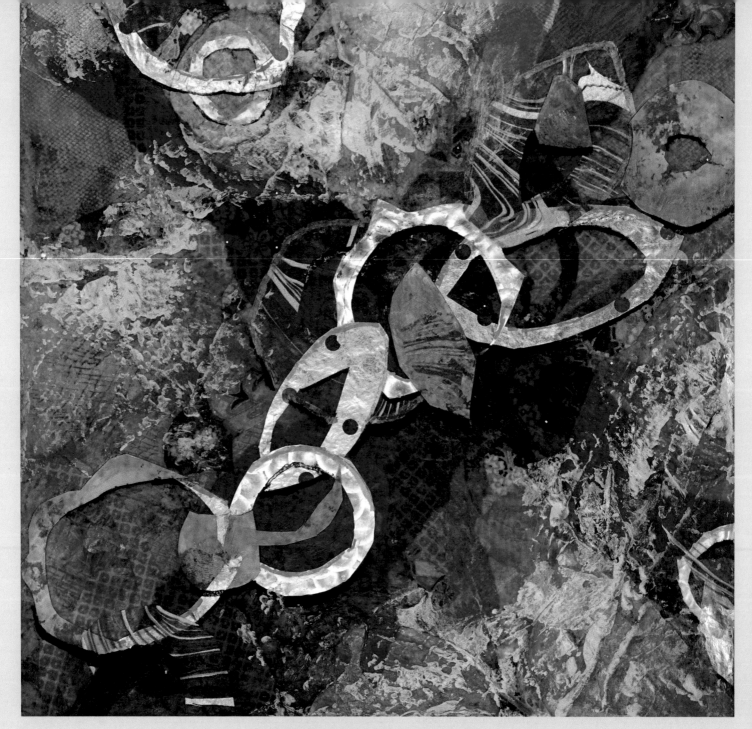

SMALL REFRESHMENTS

"A generous person will prosper; whoever refreshes others
will be refreshed." Proverbs 11:25

SMALL REFRESHMENTS

For some reason, God uses my pool exercise time to guide me in writing these devotionals. Last week as I was paddling away, I noticed my first hummingbird of the season. As these beautiful creatures migrate south, their path brings them to Houston for about six weeks beginning in late August. I put out feeders every year and love watching these remarkably tiny masterpieces of God's creation. God used this joyful sighting, leading me to ponder God's blessings both large and small.

We live in a culture that values grand gestures. Our misguided, social media driven environment tries to lure us into desiring a life filled with a never-ending parade of over-the-top events. We can end up thinking God's blessings work in the same way. We want him to bless us in huge, noteworthy ways and preferably on a daily basis.

God is certainly capable of showing up in our lives in big ways. His creation demonstrates that truth regularly. Psalm 19:1-2 says, "The heavens declare the glory of God; the skies proclaim the work of his hands. Day after day they pour forth speech; night after night they reveal knowledge." God makes some of his grand gesture blessings available to us regularly: sunrises and sunsets, the Milky Way, rainbows, majestic scenery, and the list could go on and on. Much more occasionally, we witness a miraculous healing or dramatic answer to prayer.

However, if we are only looking to God for grand gestures, we are very likely missing the myriad of small blessings he pours into our lives. On the same morning I spotted that hummingbird, I began to look for and notice several small blessings in my backyard. I enjoyed the bright green lizard adorning the drain spout. I took the time to notice the beauty of our yellow-bell blooms. God reminded me that each day he puts a plethora (love that word) of small blessings into my life, but I have to be looking for them!

During this pool time, he also reminded me that not only should we actively look for his small blessings, but we are to be people of small blessings. He may occasionally ask us to make a grand gesture in his name. Donating a kidney to a stranger or forgiving someone who murdered a loved one would certainly qualify as grand gestures. Frankly, he hasn't called me to that many grand gestures, so I am having a hard time coming up with more examples.

More often than not, God calls me to be a purveyor of small blessings each day of my ordinary life—to smile at the clerk in the store, to let that pushy person get into the lane in front of me, to show undeserved grace to someone who has wronged me, or to bring a word of encouragement or a hug to someone who is going through a rough time. Colossians 3:12-14 is a lesson on blessing others: "Therefore, as God's chosen people, holy and dearly loved, clothe yourselves with compassion, kindness, humility, gentleness and patience. Bear with each other and forgive one another if any of you has a grievance against someone. Forgive as the Lord forgave you. And over all these virtues put on love, which binds them all together in perfect unity."

Taking the time to notice the multitude of small blessings God showers on us, leads us to gratitude and then to his joy and then to sharing ourselves as blessings to others. Proverbs 11:25 underscores how God's economy works: "A generous person will prosper; whoever refreshes others will be refreshed." God's blessings do indeed refresh us spiritually. How beautiful to be able to provide his refreshment to others.

Small shapes scattered over a cross seemed to be the best way to illustrate *Small Refreshments* both bestowed and received. In God's economy all those small blessings are significant. Over a lifetime, all of these smalls add up to something really big—a life lived actively participating in the cycle of refreshment that God designed. Today might be a good day to start to live out the wisdom of Proverbs 11:25. I pray that each of us experiences his refreshment as we refresh others!

ABUNDANCE

This painting was inspired in part by a visit to Victoria Falls in Zimbabwe. The falls are over a mile wide and the water plunges 350 feet down into a gorge. With abundant rains upstream, the volume of water my husband and I saw plunge into the gorge was overwhelming and breathtaking.

This abundance started me thinking about Jesus' words in John 10:10 (NKJV), "I have come that they may have life, and that they may have it more abundantly." I think it is often easy for us to misinterpret those words from our Savior.

We may mistakenly think Jesus is promising us an abundance of things our consumer culture has convinced us is vital to our happiness. If we only had that new car, better home, bigger bank account, or that cute pair of shoes then we would experience his abundance. Perhaps we hope to experience the abundance Jesus promises if he would just make our challenging or painful circumstances vanish.

My experience has been that the abundance offered by "stuff" or even improved circumstances is fleeting. My greedy little heart always wants more "stuff" and perfection in circumstances is always just beyond my grasp. Even Victoria Falls doesn't always deliver an abundance of water. When the dry season or drought comes, the volume of water is dramatically diminished.

So where is the abundance Jesus has promised us? I found some verses in his Word, that may give us some clues.

- "How abundant are the good things that you have stored up for those who fear you, that you bestow in the sight of all, on those who take refuge in you" (Psalm 31:19).
- "They celebrate your abundant goodness and joyfully sing of your righteousness" (Psalm 145:7).

These Old Testament verses (along with many others) seem to point me to the truth that God himself is the source of our deeply desired abundance. Jesus reinforces this truth when he spoke of the most important commandment, "'Love the Lord your God with all your heart and with all your soul and with all your mind" (Matthew 22:37).

God desired so much for us to experience his abundance, that he provided a way through his Son. His abundance starts with his freely given gift of grace. In 1 Timothy 1:14, Paul says, "The grace of our Lord was poured out on me abundantly, along with the faith and love that are in Christ Jesus." The abundance God offers has nothing to do with the stuff we accumulate or whatever circumstances in which we find ourselves. His abundance transcends our circumstances and extends into eternity thanks to the work Jesus did on the cross.

God's greatest desire is for us to experience this abundance. It comes when we love him with all our hearts, when we obey him, and when we trust him. For me, the hard part is that he does not force this on me. I have a choice each moment of each day—to walk with him or to "do my own thing." My track record is so very spotty, but I found a verse I hope will inspire me to choose to walk with him. "How priceless is your unfailing love, O God! People take refuge in the shadow of your wings. They feast on the abundance of your house; you give them drink from your river of delights. For with you is the fountain of life; in your light we see light" (Psalm 36:7-9).

My prayer is that with this vision of his abundance fresh in our minds, we will become better and better at choosing to follow him moment by moment. His overwhelming and breathtaking abundance awaits!

ABUNDANCE

"The grace of our Lord was poured out on me abundantly, along with the faith and love that are in Christ Jesus." 1 Timothy 1:14

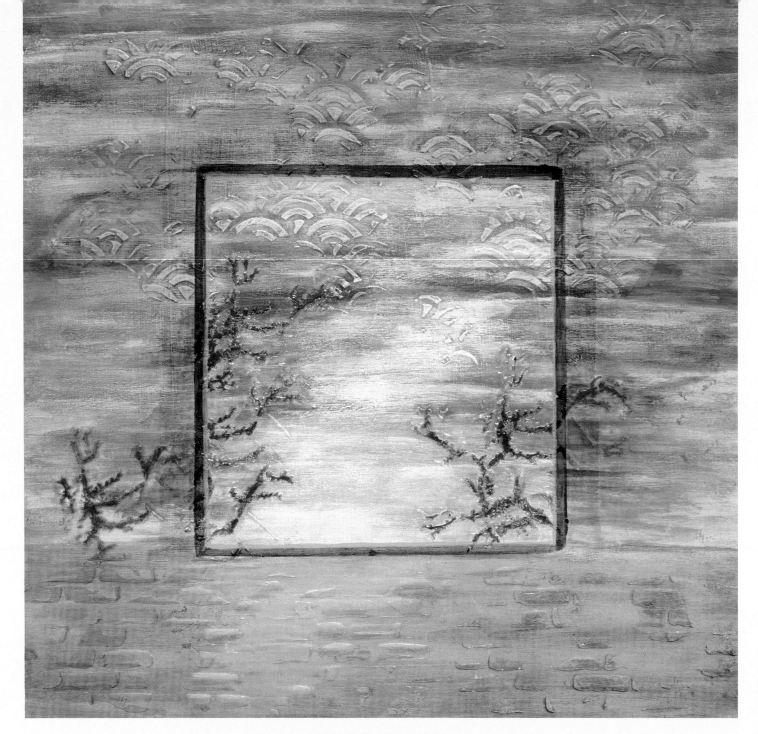

REFLECTIONS

"Let your light shine before others, that they may see your
good deeds and glorify your Father in heaven." Matthew 5:16

REFLECTING LIGHT

"Let your light shine before others, that they may see your good deeds and glorify your Father in heaven." (Matthew 5:16). This summer as I exercised in our pool early in the mornings, I would often see a reflection of the sunrise on a window of our home. I couldn't see the actual sunrise because our fence blocks my view, but I could still experience the sunrise's beauty because of the reflection—the light bouncing off of the window. This painting is my interpretation of these experiences.

I began to reflect (sorry about the pun!) on what Jesus had to say about light. In John 8:12, Jesus says, "I am the light of the world. Whoever follows me will never walk in darkness but will have the light of life." In the Matthew text, Jesus tells us to let our light shine and in the John text, Jesus says that he is the light. Are these verses contradicting one another? Who has the light? And by the way, what is this light I am supposed to have?

John 9:5 helped me to solve the contradiction issue. Jesus says, "While I am in the world, I am the light of the world." I am not a theologian or even close, but when I look at this scripture along with the others, it seems Jesus assigned us the task of being his light in the world after he ascended into heaven.

So what is his light that I'm to shine before others? I have been in a women's Bible study recently, and we are working our way through 1st, 2nd, and 3rd John. The apostle John has a great deal to say about both God as light (pure, good, and holy) and God as love (providing a way for us to be pure, good, and holy through the gift of his Son). After rolling these two characteristics of God around in my brain, I came to the conclusion that my light has to be God's love. I think the apostle Paul reinforces this idea in 1 Corinthians 13:1-3. He says, "If I speak in the tongues of men or of angels, but do not have love, I am only a resounding gong or a clanging cymbal. If I have the gift of prophecy and can fathom all mysteries and all knowledge, and if I have a faith that can move mountains, but do not have love, I am nothing. If I give all I possess to the poor and give over my body to hardship that I may boast, but do not have love, I gain nothing."

So I need to let my light shine before others. I don't know about your light, but my light is subject to flickering and fading. When winds of doubt and worry blow, my light is not always steady and strong. My love is fickle and faltering. It frequently is tainted by self-absorption and pride.

I think I am supposed to be like my window. The light from the sunrise comes flooding into my home through the window. At the same time, the light reflects off the window so anyone looking at the window from the outside sees the sunrise as well. I need God's light and love to flood my life. My own light and love are way too weak and unreliable. They don't reflect an accurate picture of God's light and love. The good news is through the power of the Holy Spirit, his love and light can fill my heart so the light I shine on others becomes a much better representation of God's pure light and extravagant love for us. This is the task Jesus has given us. In Matthew 5:16, you'll notice the goal is for others to see our love demonstrated in good works but not so we receive honor and glory. Our goal is for others to glorify our Father in heaven.

Now there is the matter of keeping that window clean, so the reflection isn't distorted or blocked, and all the glory goes where it belongs. But I think that is another devotion! My prayer is that through the Holy Spirit, God will flood each of our hearts with his light and love; purifying our motives along the way so others see past us and catch a glimpse of his glory.

JOURNEY INTO OBEDIENCE

"I ask that we love one another. And this is love: that we walk in obedience to his commands. As you have heard from the beginning, his command is that you walk in love" (2 John 5-6).

A couple of years ago, I launched a devotional website. I didn't do this because I was equipped or trained to build a website, or to paint, or even to write devotionals. I did this because I felt God calling me to do this crazy thing! I immediately obeyed him and here I am still writing and painting.

Now my normal response to God's call is NOT immediate obedience. I wish that were the case, but my normal response is more like: "That doesn't fit in with my plans," or "I'll think about that later," or "If I ignore this for long enough maybe it will go away." For some reason his tug on my heart two years ago was so strong, that I couldn't ignore it or postpone it. I think God wanted to teach me a few things about obedience.

The verse that accompanies this painting above was unfamiliar to me until this week, but it tells me obedience is the product of love—love for God. Jesus was pretty clear about obedience too. In Luke 11:28 Jesus says, "Blessed are those who hear the word of God and obey it."

My love of God must be based on my trust in him. Scripture is chock-full of evidence of God's love for us, and his desires for the absolute best for each of us. Scripture assures me that God's plans for me will advance his purposes and bring me joy and fulfillment (Jeremiah 29:11). So why in the world, do I resist his plans so regularly? Why do I think my own plans will bring me more fulfillment? Frankly, the evil one fills my head with his lies, I am susceptible, and my trust withers and fades.

Even when we obey God's call for us, the evil one is not through with his deceit. We think, "If I am doing what God has called me to do, surely the road will be smooth and obstacle free!" This is a lie of satanic proportions. This painting reminds me of what happened to the apostle Paul after he heeded the call of God. He went from being a respected synagogue leader to a shipwrecked itinerant preacher, an inmate, and ultimately a martyr. He obediently walked right into a storm. Despite all of that, Paul was filled with gratitude, love, and joy which, frankly, seems unnatural.

Obeying God's call won't necessarily make us a success as the world defines it. Obedience doesn't remove all the obstacles, problems, and storms in our lives. What it offers is far more valuable. It draws us closer to the One in whom "we live and move and have our being" (Acts 17:28). In Philippians 3:8 Paul says, "What is more, I consider everything a loss because of the surpassing worth of knowing Christ Jesus my Lord, for whose sake I have lost all things. I consider them garbage, that I may gain Christ." He was able to see his situation from God's eternal perspective rather than the world's view, enabling him to experience "unnatural" gratitude, love, and joy.

Ephesians 2:10 tells us, "For we are God's handiwork, created in Christ Jesus to do good works, which God prepared in advance for us to do." God has things for us to do! Obedience is the only way to accomplish what God has prepared for me. I really shudder to think of all the opportunities to know him better that I have already passed up. I pray that through the power of the Holy Spirit, my love and trust for God will remain strong when I hear his call. My prayer for you is the same. Through our obedience he offers us himself and the joy and fulfillment that come from knowing him. What a gift!

OBEDIENCE

"And this is love: that we walk in obedience to his commands. As you have heard from the beginning, his command is that you walk in love." 2 John 6

CITY ON A HILL

"You are the light of the world. A town built on a hill cannot be hidden."
Matthew 5:14

POWER SOURCE

I recently heard a sermon about the Holy Spirit and the impact it had on the early church. There were a couple of points in the sermon that really spoke to me.

The first point convicted me. Like the early church, we are called to be the light of Christ in this world. I began pondering how consistently (or not!) my light shines in my little part of the world. In Matthew 5:14, Jesus told us, "You are the light of the world. A town built on a hill cannot be hidden." I am all too prone to let my light flicker and fade. My behavior isn't always Christ-like. I have trouble being a steady, consistent light that isn't hidden from view.

The second point was about the Holy Spirit. When we accept Christ as our Savior and are baptized, we receive the Holy Spirit. The second part of the point was intriguing. The Holy Spirit lives within us to restore our image into the likeness of God. In my case the Holy Spirit has a big job to do. That job includes equipping me to be a light in the world—not any old light, but the light of Christ. Now that I think about it; the light of Christ is pretty identical to the likeness of God.

At home, my typical light sources are powered by an electrical current out of a socket or batteries. If I need light, I have to choose to plug in or power up.

Spiritually, if I want to be the light of Christ in the world, I need a source of power. That power is, of course, the Holy Spirit. While he is within me, he doesn't overpower my will. I have to choose to access his power. My problem is that often I choose to ignore my power source. When I do choose to plug in, I tend to trip over the cord, unplug, and keep going without my power source. I shouldn't be surprised when no light of Christ shines.

In his epistles, Paul shared what would happen if we "plugged in" to the Holy Spirit:

- "But the fruit of the Spirit is love, joy, peace, forebearance, kindness, goodness, faithfulness, gentleness and self-control. Against such things there is no law" (Galatians 5:22-23).
- "May the God of hope fill you with all joy and peace as you trust in him, so that you may overflow with hope by the power of the Holy Spirit" (Romans 15:13).

The fruit of the spirit and the hope we have in Christ are the very essence of the light we are called to be. I need to be plugged into the Holy Spirit every moment of the day. I know that I will fall short of this daily, but wouldn't it be nice if each day I was plugged into my power source a bit longer than the day before?

The early church changed the world as their light spread the good news of Christ. How beautiful to think of his light shining a little bit brighter and stronger each day through us. In this painting I tried to depict the *City on a Hill* Christ described Matthew 5. Like that city, we have the opportunity to brighten our little part of the world through his power and for his glory. Let's do it!

GRATEFUL

Before I started my website, I was told I should have six months' worth of content ready before launching the site. For me that meant twenty-six devotionals already written. I had zero! God, however, gave me a strong sense that I was to ignore this "worldly wisdom" and simply trust him to provide. So here I am writing a devotional that is far beyond number twenty-six and trusting God will continue to provide me topics to write about.

Now let me acknowledge up front that the topic the Lord has given me for this week, gratitude, might be more timely later in the fall, but hey, it's what he wants me to write about. And more than that, he wants me to live as a grateful person.

The Bible is full of many examples of gratitude and thanksgiving, but I've focused on three examples of grateful people that stood out for me: David, Jesus, and Paul. In looking at their expressions of gratitude, I identified three tips on living in gratitude.

The Psalms are chock-full of David's expressions of gratitude. The volume of his expressions tells me he lived as a grateful person. Now David had his ups and downs (don't we all), but he had a grateful heart in the midst of the highs and the lows. Psalms 105 and 106 give us clues about the secret to having a grateful heart. They both start with exhortations to give thanks or praise to the Lord. Psalm 105 recounts the faithfulness of God through the history of the Israelites. In Psalm 106, David remembers God's faithfulness, love, and mercy for his people in spite of their sinfulness. The truth that emerges is this: a grateful heart comes, in part, from remembering what God has done in our lives. Sometimes I can be very forgetful when it comes to recalling how God blessed me. I get caught up in my current worry or fret and deny myself the peace that would come from remembering his history of faithfulness and provision for me.

Since Jesus lived without sinning, I can only conclude that he must have lived as a grateful person. The Bible contains many of his words and deeds that reflect that reality, but I was struck by the times that he explicitly thanked God. Those times were when Jesus was sharing a meal, either with thousands (Matthew 14:19 and 15:36) or just his disciples (Matthew 26:26-27). Jesus thanked God for his provision in the present moment. He wasn't looking back to the past or into the future. I think we, too, are called to thank God for what he is doing right now, whether it is a meal or a blessing that has come our way (small or large). So often I am focused on my plans and my desires that I am blinded to his "right now" provisions for me. God knows I will find joy when I ask the Holy Spirit to open my eyes to see how he sprinkles his abundant blessings into my life each day.

The apostle Paul probably used the word "thanks" more than any other person in the Bible. He thanked God for all kinds of things. What struck me this week was that in almost all of his letters he used some version of the phrase, "I thank God for you." He was profoundly grateful for the people who walked with him during his faith journey and he sincerely expressed his gratitude to them. There are people in my life for whom I am profoundly thankful but how often do I voice this gratitude? I wonder how many opportunities I have missed when God desired for me to encourage or bless someone with my thanks?

So, our tips for grateful living from David, Jesus, and Paul are:
- Remember how God has faithfully worked in our lives.
- Look for his blessings that are all around us each day.
- Tell people how much you appreciate them.

The painting this week is called *Greatest Gift*. It definitely has a Christmas theme, but perhaps in thinking about Christ's birth, we may find a fourth tip. I don't think it is overstating it to say that all our gratitude springs from our response to God's gift to us in Jesus Christ. I know that, but again, I find I take it for granted and don't express my gratitude to God often enough or fervently enough. In 2 Corinthians 9:15, Paul utters what should be constantly in my heart and on my lips, "Thanks be to God for his indescribable gift!"

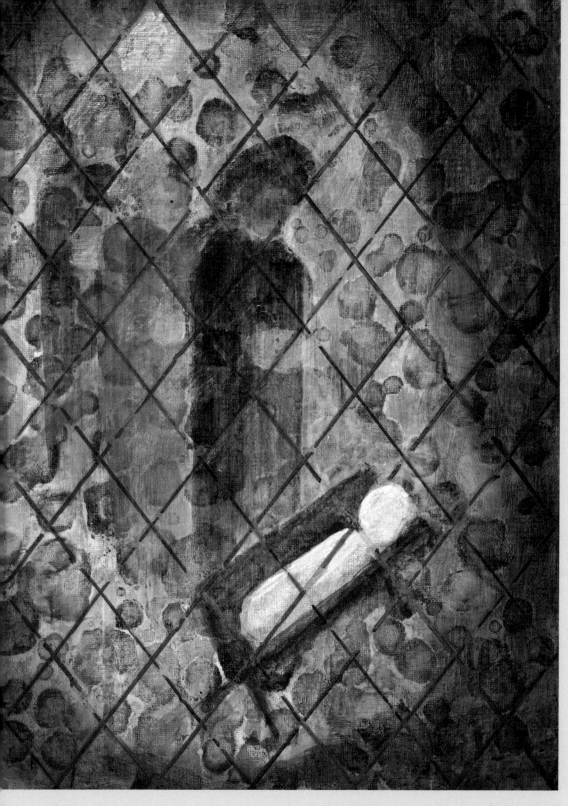

These aren't particularly profound insights, but I get so caught up in the business of the day that I find myself missing out on the joy and peace God designed to spring from a grateful heart. This week I'm going to try (with the help of the Holy Spirit) to practice these tips consistently. Why not join me?

GREATEST GIFT

"For to us a child is born, to us a son is given, and the government will be on his shoulders. And he will be called Wonderful Counselor, Mighty God, Everlasting Father, Prince of Peace."
Isaiah 9:6

CROSSROADS

"Stand at the crossroads and look; ask for the ancient path,
ask where the good way is, and walk in it,
and you will find rest for your souls." Jeremiah 6:16

STARTING AND STAYING

We start things daily. We start a new day when we wake up. We often start a new task, project, or even a new job. We may start a new relationship or start a conversation with a beloved family member or friend. Sometimes we have to start treatment for an unwanted disease or start to deal with an unhealthy relationship. Starts are an important part of our lives, so this past week I started thinking about starting (sorry, I couldn't help myself!).

If we go back to the beginning, it all started with God as it tells us in Genesis 1:1, "In the beginning God created the heavens and the earth." God's co-worker in creation was Jesus. John 1:3 says, "Through him all things were made; without him nothing was made that has been made."

Since he created each of us and "in him we live and move and have our being" (Acts 17:28), it seems we should start each day with him. Now I readily acknowledge this is not my original idea, but sometimes I need to be reminded! Lamentations 3:22-23 tells us he has new compassions for us each morning because of his great love for us. Spending time with him, surrendering our plan for the day to him, and listening to him for his plan is an ideal way to begin each day. My starts are not always ideal. I have big-time trouble with that surrender part and listening is not my forté.

The thing is, even if I get off to a pretty good start in the morning with God, I'm a little shaky on staying with him during the day. Ideally, I would consistently follow his plan for my day and invite him to be my counselor and guide for all those other "starts" that occur. More typically, my surrender to his plan for me is short-lived and my plan for the day is the path I choose to follow. I may or may not remember to include him as various "starts" pop-up.

Staying with God through all the "starts" is just as important as starting with him. And by the way, all those starts require some staying power. The apostle Paul is a sterling example of staying with the plan God had for him. In 2 Timothy 4:7 he says, "I have fought the good fight, I have finished the race, I have kept the faith."

Let me use my car's GPS system as an analogy for all this starting and staying. After entering a desired destination into the system, my GPS gives me step by step directions from my starting point. It doesn't give me all the directions, however, so I don't know the whole route. Perhaps I have trust issues with my GPS, but this drives me crazy! I like to see the whole route, so I pull up Google Maps and take a look to see if I agree with what my car's GPS says.

God works more like my car's GPS than Google Maps! If I start my day with him, he gives me enough guidance to get me going and then if I stay tuned into him, he will continue to guide me to the destination he desires for me. God generally doesn't show me the entire route at the beginning of the day.

When I am driving it is not unusual for me to think I know a better route than my GPS. I go my own way while my GPS keeps recalculating, trying to get me back on the path. How often do I do that with God? I don't stick with him during my day and use my own faulty wisdom to chart my course. It is sad that my trust in God is about the same as my trust in my GPS. However, he is there waiting for me to surrender my will (again) and ready to guide me back to the path he designed for me. Jesus knew my propensity for this when he told the parable of the Lost (Prodigal) Son in Luke 15:11-32. I may not wander as far and as long, but I wander nevertheless.

The prophet, Jeremiah, provides us some wisdom for staying with God throughout each day. "Stand at the crossroads and look; ask for the ancient path, ask where is the good way, and walk in it, and you will find rest for your souls" (Jeremiah 6:16). This painting, *Crossroads*, depicts the myriad of crossroads we encounter each day—each an opportunity to stay connected with God's ideal route.

Starting and staying with him—it is a simple truth that is hard for me to live out daily. I forget the destination he has planned for me is far better than what I have planned. Could it be I am not the only one with this problem? Holy Spirit, through your power I pray that tomorrow our starting and staying will better reflect our gratitude for your unfailing love and mercy.

REST FOR THE SOUL

I have been super busy and maybe that's why I've been thinking about resting. Just as physical rest is important to our health, spiritual rest is vital to our spiritual well-being.

At the very beginning, God established rest when on the seventh day of creation he rested. He modeled the importance of rest and established it as holy. Christ reinforced rest as vital when he said, "Come to me, all you who are weary and burdened, and I will give you rest" (Matthew 11:28). God offers us spiritual rest in the midst of life's challenges but doesn't impose it on us; we have to choose to accept the invitation.

Scripture gives us some insights into resting in him. Psalm 62:5-8 says, "Yes, my soul, find rest in God; my hope comes from him . . . Trust in him at all times, you people; pour out your hearts to him, for God is our refuge." The Bible also gives us several visuals of what resting in him might look like. I think he knew we might need some earthly context for this spiritual experience. Psalm 91:4 provides us one picture, "He will cover you with his feathers, and under his wings you will find refuge." Psalm 23 visualizes taking a walk with him, "He makes me lie down in green pastures, he leads me beside quiet waters, he refreshes my soul."

Despite these scriptural insights, resting in God is a concept I have grappled with for some time. I'm not a good "rester." I am a doer, so what does one do while resting in him? Is it just reading the Bible and praying? Rest certainly includes these but I'm learning that resting in God is not so much about doing as being:

- Being in his presence.
- Being worthy to be in his presence because of Jesus' work on the cross.
- Being embraced by his perfect and unfailing love.
- Being still and listening for his voice.
- Being assured of an eternity in his presence.
- Being given a little foretaste of the peace and joy that awaits me in my eternal home.

I am learning I can rest in his presence, when I set aside my agenda for his and when I shift my focus from me to him. Then he can fill my soul with what I truly need. Letting go of my self-absorption doesn't come easily for me. Sometimes, I have to confess what is really going on in my heart and ask him to purify my motives before I can truly rest in him. This is the painful part and I am a pain avoider.

I'm learning that like most things that are good for us, resting in him takes practice and persistence. I have trouble sustaining my resting for very long, but I know God will be faithful to help me rein in my restless mind, if I just sincerely ask him for his help. The psalmist models this behavior in Psalm 62:5, "Yes, my soul, find rest in God; my hope comes from him." In this painting, *Harbor of Rest*, I have depicted a safe harbor, a place to rest in the midst of stormy seas. God longs to provide this for us. He knows how much we need it!

A refreshed soul, a quiet spirit filled with hope and peace: these are the benefits of resting in him. These blessings are often not found in all my "doing." In Mark 6:31, when the disciples returned from their initial mission, Jesus said to them, "Come with me by yourselves to a quiet place and get some rest." It's an open invitation—always available. RSVP to him with a Yes!

HARBOR OF REST

"Yes, my soul, find rest in God; my hope comes from him." Psalm 62:5

MOMENTUM

"I press on toward the goal to win the prize for which God has
called me heavenward in Christ Jesus." Philippians 3:14

MAINTAINING MOMENTUM

One of my favorite verses is Philippians 3:12-14: "Not that I . . . have already arrived at my goal, but I press on to take hold of that for which Christ Jesus took hold of me. Brothers and sisters, I do not consider myself yet to have taken hold of it. But one thing I do: Forgetting what is behind and straining toward what is ahead, I press on toward the goal to win the prize for which God has called me heavenward in Christ Jesus."

The apostle Paul communicates such energy and focus in these verses. To press on is intentional and energetic. It a choice. Rather than drifting along, we can choose to press on. Because of all the hardships Paul endured, it is easy to conclude that Paul's advice was meant to apply only to hard times. However, Paul had a deep and personal understanding of our sinful natures which leads me to believe he is talking about pressing on regardless of circumstances. I am likely to ease up on pressing on when times are good, and no crisis is looming. That is when the evil one tries to convince me I can get by on my own power and wisdom. If I fall for that lie, then some kind of disaster is inevitable!

So how do we maintain the momentum and energy required to press on? Scripture provides some clues as to how to maintain our momentum for pressing on and they all start with the letter R.

Paul starts Philippians 3 with "rejoice in the Lord." Grateful hearts are foundational to pressing on. Focusing on the eternal grace and mercy given to us in Christ motivates us to respond to his love with energy and focus.

Secondly, Paul tells us the renewing of our minds (Romans 12:2) is key to transforming us from those who are likely to just drift along clinging to the world's wisdom to those who will press on toward being transformed into the people God has called us to be.

Renewing our minds happens when we remain in him. John 15:5 says, "I am the vine; you are the branches. If you remain in me and I in you, you will bear much fruit; apart from me you can do nothing." Remaining in him requires time in his Word and in conversation with him through prayer. We often long for shortcuts but remaining in him calls for a commitment of our time. Remaining is woven into the fabric of pressing on.

Lastly, we must rely on the Holy Spirit. Jesus promised us power from the Holy Spirit to carry out his mission in the world (Acts 1:8). Our own power is far too weak to maintain the momentum we need to press on. If I rely on my own strength, my energy is soon gone, and I find myself drifting and wandering and even wavering in my faith.

The prize we press toward is not kept only in heaven. The prize is an intimate relationship right now (and eternally) with the Maker of all creation who knows each of us completely and loves us fiercely.

I'll be the first to admit that this painting is a bit strange. I chose it to go with this devotional primarily because of the wing-like shapes. Pressing on takes action and energy and each of us can maintain our momentum only through choosing to don spiritual "wings" fueled by the those Rs. Our wings won't be visible, but their results will be evident in our daily lives. These wings are always available but we all have to make the choice to ask for them and to use them as we press on to his life-giving and priceless prize. Lord, through the power of your Holy Spirit, enable us to maintain the momentum and press into you and what you have called each of us to be.

SAVOR AND STEEP

I eat too fast. It is a bad habit that probably came from years of operating in high-paced business environments. I am learning that when I just gulp my food down, I miss out on the full experience and enjoyment that can come from a meal. I miss out on a leisurely, relaxing, and reviving experience in exchange for a hurried, indigestion-inducing gobble. If I take the time to savor each bite and sip my beverage, an ordinary meal can be transformed into something wonderful!

When the psalmist invites us to "taste and see that the Lord is good" (Psalm 34:8a), I think he is inviting us to partake in a feast of communing with God. Feasts are not hurriedly done. There are many courses served at a leisurely pace. A feast is orchestrated to allow time to savor each bite and discover the food's many nuances of flavor and texture as well as to connect with those who are at the table. We come away from a feast not only physically nourished but also with a deeper connection to those with whom we shared the meal.

Each day we have the opportunity to "taste and see that the Lord is good." God's feast is always available to us. He desires to feast with us in an unhurried fashion. As we are in his presence, we recall the nuances of how we have experienced his love and provision. Our spirits can be sweetened with thanksgiving as we express our gratitude for God's mercy and grace. Our souls are nourished as we read his Word and steep in the truths we find. The Psalms express it much more poetically than I can. Psalm 36:8 says, "They feast on the abundance of your house; you give them drink from your river of delights." Psalm 119:103 tells us, "How sweet are your words to my taste, sweeter than honey to my mouth!"

When friends told me this painting looked like a dessert, it seemed like a perfect fit for this devotional. I hope it reminds us of the wonderful spiritual food God longs to share with us. He wants us to savor every moment with him so he can nourish our souls.

Sometimes my time with God is like taking a tea bag and dipping it in hot water one time. That makes for pretty weak tea! I'm in a hurry and I don't take the time to savor my time with him or steep myself in his Word. Jesus knew about people like me when he said, "Do not work for food that spoils, but for food that endures to eternal life, which the Son of Man will give you" (John 6:27). In my rush to move on to things that have no eternal value, I deprive myself of a feast with eternal delights. How crazy is that?

Let's all take the time this week to savor God's presence and steep ourselves in his company and his truth. His table is always set, and his food for our souls nourishes and sweetens our lives now and into eternity.

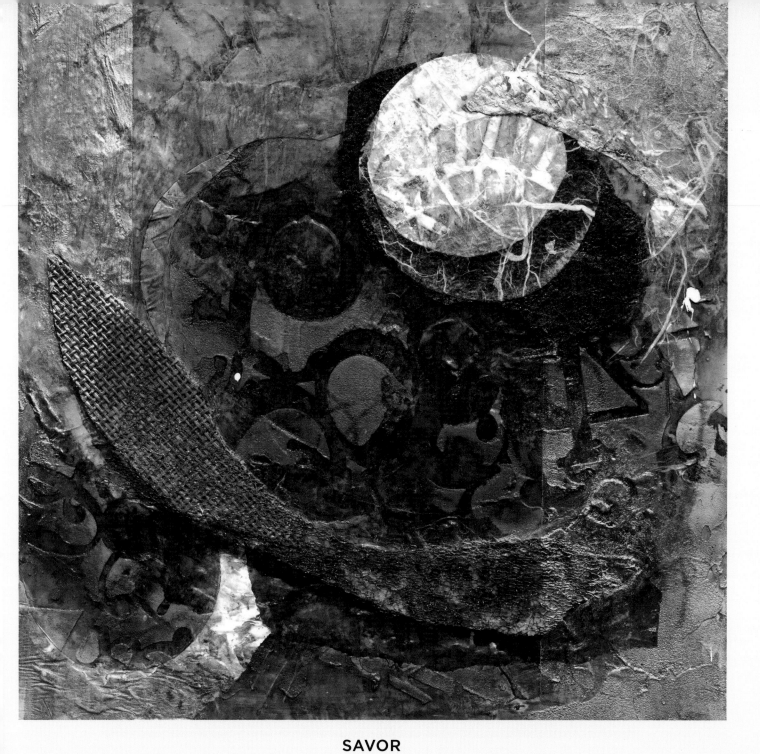

SAVOR

"Taste and see that the Lord is good." Psalm 34:8a

MANY ROOMS

"My Father's house has many rooms . . ." John 14:2a

FILL HIS ROOMS!

For some time, I have wanted to paint a piece to accompany John 14:2a, "My Father's house has many rooms." It wasn't until this week that God enabled this painting. As I was painting, I spent some time reflecting on these words of Jesus.

Jesus spoke these reassuring words to his disciples at the Last Supper after reminding them that he would be leaving them soon. He lovingly let them know he was going to prepare an eternal home for them; assuring them that they would be reunited with him.

Fortunately, those words don't apply just to those twelve first disciples. Jesus didn't say, "My Father's house has twelve rooms, one for each of you!" Jesus' reassuring words apply to each of us who follow Christ. The house Jesus has prepared for us has many, many rooms—rooms for each of us who believe in him!

It occurred to me that there could be more to these words than just reassurance. There is a call to action embedded in these words. Jesus was always pretty clear that the work of spreading the gospel was to be done by his disciples. He called Peter and Andrew to be "fishers of men" and immediately before he ascended into heaven, Jesus told his disciples to go and make other disciples (Matthew 28:19).

I don't think it is too far a stretch to imagine Jesus saying to us, "Go, fill up those rooms!" I think filling up his rooms is part of Paul's message to us in Ephesians 2:10, "For we are God's handiwork, created in Christ Jesus to do good works, which God prepared in advance for us to do."

Making new disciples and filling up his rooms is what we are all called to do. Thankfully, we aren't all supposed to fulfill our mission in exactly the same way. As God's handiwork (or masterpiece!) we each have unique talents and spiritual gifts to use. What we all have in common is the empowering presence of the Holy Spirit within, enabling us to accomplish what God has prepared for us to do.

I know that I fall short in this area. I can't count the number of times when I have had an opportunity to share the gospel and failed to do so. I also suffer from the desire to know the outcome when I do manage to have the guts to say something.

What I have begun to learn is to just be obedient. When I sense he wants me to say something, or write something, or paint something—just do it. Equally important, I am learning to let go of my desire to know the results. He's in charge of the results, I'm not. My part in filling rooms in his house is small, but God uses all of our small "obediences" for his purposes.

Jesus wants us all to help fill up his rooms. He calls us to listen, obey, and then let him handle the rest. It sounds easy but he knows how difficult it is for us to listen, obey and let go in this broken world. His Spirit stands ready to help us fill up those rooms!

Father, create in us a desire to fill your rooms with those whom you have chosen for us to share the gospel. Tune our ears to your voice. Give us the strength and courage to obey and the wisdom to leave the outcome in your loving hands. Amen.

TWENTY-THREE BRUSHES

Based on the title, I'll bet you thought this devotional was going to be about painting. However, this tidbit has nothing to do with painting!

A few days ago, I opened a bathroom drawer to grab my makeup bag. I noticed that the compartment next to my bag was very cluttered. Upon closer inspection, I found a collection of make-up brushes of all shapes and sizes—twenty-three makeup brushes. Who needs that many? I have four in my makeup bag that I use regularly, but the rest were just cluttering up my drawer. After an internal debate, I decided the reasonable thing to do was to get rid of all but four (we all need back-ups!) of the twenty-three. Nineteen brushes hit the trash can!

This incident started me thinking about both physical and spiritual clutter. My husband, Ron, and I are both pretty neat people and our home doesn't have a whole lot of visible clutter. However, I have a few closets and drawers that hide a pretty good collection of stuff. Ron's clutter resides in the garage. We each have clutter; you just have to know where to look.

Spiritually, we are often the same way (at least I am!). On the surface, we try to look like we have it all together but, in our hearts, we have all kinds of spiritual clutter that is clogging up the works. This painting, *All Tangled Up*, provides a visual on the tangle of clutter clogging up our soul, although the clutter in my heart is probably not nearly as colorful and attractive! In Hebrews 12:1-2, Paul tells us to get rid of that clutter, "let us throw off everything that hinders and the sin that so easily entangles. And let us run with perseverance the race marked out for us, fixing our eyes on Jesus, the pioneer and perfecter of faith."

I think there are two kinds of spiritual clutter. The first is the "pretty" clutter; things that are not inherently bad but distract us from God. Family is a good example. Family is a gift from God, but God never intended for them (or any other of his good gifts) to be our number one priority. That is reserved for him. When our priorities are not right, we are hindered from living out God's purposes for us.

The second kind of clutter is sin—ugly clutter. Satan tries to dress it up in pretty clothes and convince us it's not really so bad, but it is destructive to our souls. We find ourselves entangled in the lies and half-lies of Satan and find it hard to see our sin from God's perspective and how it separates us from him. Paul hits this topic again in 2 Corinthians 7:1 as he tells us, "Let's make a clean break with everything that defiles or distracts us, both within and without. Let's make our entire lives fit and holy temples for the worship of God" (MSG).

In order to break free of our sin (especially from the ones we are friendly with), we need his help. The good news is that he freely offers the help we need. 1 John 1:9 reassures us, "But if we confess our sins to him, he is faithful and just to forgive us our sins and to cleanse us from all wickedness" (NLT).

The payoff for getting rid of our spiritual clutter is pretty special. Paul speaks again in 2 Timothy 2:21: "If you keep yourself pure, you will be a special utensil for honorable use. Your life will be clean, and you will be ready for the Master to use you for every good work" (NLT).

The tough thing about clutter (physical and spiritual) is it has a bad habit of returning even after we have cleaned it out. The good news is that Jesus is faithful and stands ready to help us clear out the mess. We just have to ask. I have found he doesn't mind if I come to him daily asking him to clean up my heart!

P.S. I have to confess my painting room is horribly messy and cluttered. I think God understands!

ALL TANGLED UP

"Let us throw off everything that hinders and the sin that so easily entangles.
And let us run with perseverance the race marked out for us, fixing our eyes on Jesus,
the pioneer and perfecter of our faith." Hebrews 12:1-2

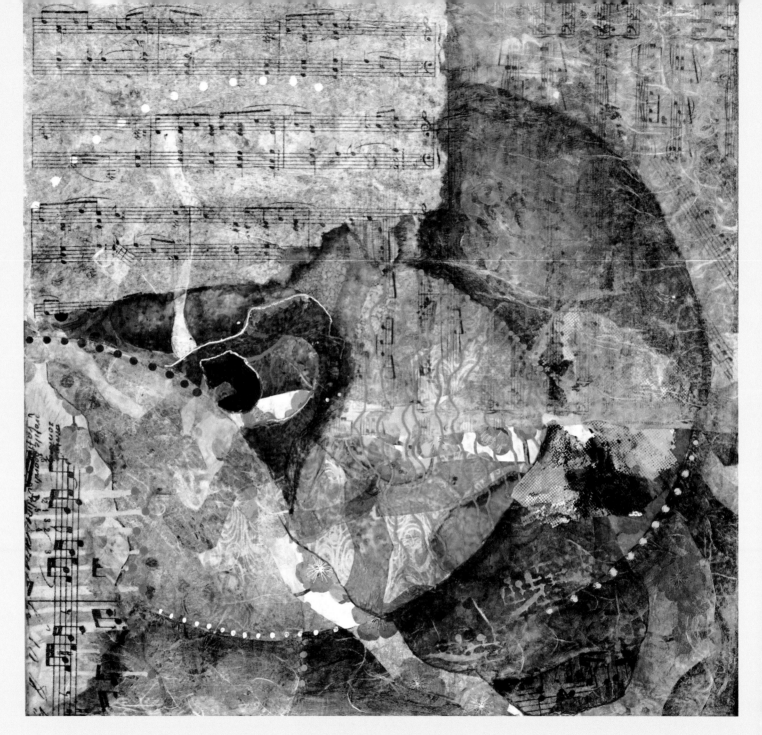

MUSIC TO MY EARS

"Incline your ear and come to Me. Hear, and your soul will live." Isaiah 55:3 (NKJV)

MUSIC TO OUR EARS

I have a new favorite verse: "Incline your ear and come to me. Hear and your soul will live." I recently discovered Isaiah 55:3 (NKJV) in one of my devotional books and it resonates with me in a big way.

There is a whole lot of meaning packed into this verse's two short sentences. The words, "your soul will live," struck me right between the eyes. Our souls, as I understand it, are the eternal part of each of us that endure beyond our temporary earthly bodies. This verse tells me that the health of my soul is very dependent on my listening to God. Since listening is not my forté, I thought the whole issue of my soul's health warranted further investigation.

I went back to Isaiah 55 and read verse 2, "Why do you spend money on what is not bread and your wages for what does not satisfy? Listen carefully to Me, and eat what is good, and let your soul delight itself in abundance" (NKJV). Wow! Further reinforcement that our souls live and thrive when we listen carefully to our God. He is the source of the spiritual sustenance that we need. He knows what is best for us and moves us from just existing to really living and thriving in his abundance.

Several verses in the Psalms reinforce that truth:

- "My soul thirsts for God, for the living God. When can I go and meet with God?" (Psalm 42:2).
- "Truly my soul finds rest in God, my salvation comes from him" (Psalm 62:1).
- "My soul yearns, even faints, for the courts of the Lord; my heart and my flesh cry out for the living God" (Psalm 84:2).

Our souls desperately need to hear from their Creator. He must be the center of our lives, our primary focus, and that doesn't happen unless we listen to him continually. So how do we listen?

Since the Bible is his Word, certainly we can expect to hear from him as we read and study it. I don't know if anyone else has this problem, but I have been known to "read" the Bible without my mind or heart particularly engaged—without my ear inclined. When Isaiah 55:3 really captured my attention, somehow, I had managed to incline my ear and God had something to say to me. When we read his word, we have to do it with our ear inclined, expecting to hear from him. For me, I have to slow down, focus, and truly think about what his Word is saying.

Obviously, prayer is another opportunity to listen to God, but often I'm so busy blabbing that I never incline my ear to hear from him. When I do hear God speaking to me through prayer, I don't literally hear a voice, but in a mysterious way I can discern that the thought that just popped into my head was not my thought, but his voice. Sometimes God does speak to us using the "two-by-four upside of the head" method, but more often than not, he uses a quiet stirring in our souls to communicate with us. Isaiah 55:2 says we must listen carefully and the verbs in Isaiah 55:3 (incline, come, hear) are all action words. Listening to God is active and intentional. It requires effort!

As I tried to paint something to illustrate these verses I struggled. Even though I was painting about listening to God, I was not listening to him while I painted. Finally, I sought his wisdom for the painting and he slowly began to reveal the next steps to take. As I was finishing, I realized that through his guidance, a suggestion of the anatomy of the inner ear had emerged. I had to check on Google to make sure, but there it was. God was making sure I didn't miss the truths of his prophet Isaiah.

The beautiful truth of these verses is that as we listen to the voice of our God, he is faithful to give abundant life to our souls as we hear a beautiful melody of his love and grace and peace and joy. It is music to our ears and to our souls!

WORKING FOR THE ALPHA AND OMEGA

"I am the Alpha and the Omega, the First and the Last, the Beginning and the End" (Revelation 22:13).

This morning I took on the task of power-washing our driveway and sidewalks. I was motivated to do this by a "nastygram" from our Homeowners' Association who had determined our cement slabs were not up to their cleanliness standards. Some years ago, my husband and I concluded that the person who had the highest level of Obsessive Compulsive Disorder in their personality was the person who should do power-washing; therefore, I was the anointed one for this task.

If you've never done it before, power-washing is dirty, noisy, wet, tedious, and boring. Mostly you spend your time just wanting it to be finished! As I started my work this morning, a piece of a Bible verse popped into my head.

"Whatever you do, work at it with all your heart, as working for the Lord, not for human masters" (Colossians 3:23).

This was a gift from God. It changed my whole experience. I started thinking about how amazingly wonderful it was that the God of all creation, the Alpha and Omega, was interested in how I did this job and every job I undertake.

Some of the work I do has more obvious connections with God's desires for me. I certainly am thinking and praying about pleasing him when I write these devotionals and paint. But God is just as interested in how I do my power-washing, laundry folding, dishwasher loading, and countless other mundane tasks.

As I contemplated the verse this morning, I realized my mundane task had been transformed into a task with meaning and purpose. I wanted to do my best for him. Since I was thinking about him, my work became a form of worship and communion with him. He used that time to plant the seeds for this devotional.

In 1 Thessalonians 5:17, Paul says, "Pray continually." The apostle Paul knew if we make our work an offering to him then we have begun to move in the direction of praying continually. God's deepest desire is to be involved in absolutely everything in our lives.

Our Alpha and Omega blessed me this morning as I made the choice to clean my driveway for him. He transformed an irksome task into a time of rich communion with him. Revelation 21:6 says, "I am the Alpha and the Omega, the Beginning and the End. To the thirsty I will give water without cost from the spring of the water of life." I think we are all thirsty for our work to have meaning and purpose. He is the only One that can give all our tasks eternal meaning and purpose. To God be the Glory!

P.S. Any painter that tries to portray the eternal nature of God is trying to depict the undepictable. I forged ahead anyway and chose to use celestial shapes on a fairly small canvas despite knowing that even real photographs of the heavens don't do him justice. Given his loving and forgiving nature, I like to think he smiled when he saw it.

ALPHA AND OMEGA

"I am the Alpha and the Omega, the First and the Last,
the Beginning and the End." Revelation 22:13

HOPE

"May the God of hope fill you with all joy and peace as you trust in him, so that you may overflow with hope by the power of the Holy Spirit."
Romans 15:13

THE PATH TO HOPE

Every week I wonder, "What will I write a devotional about this week?" Usually my mind is totally void of ideas and I hope the Holy Spirit will give me inspiration and then the words to write. I remembered a painting I did a couple of months ago titled, *Hope*, so here I am, hoping the Spirit will give me his words. Sure enough, the Bible verse I had chosen to go along with this painting, started me down the path to hope. "May the God of hope fill you with all joy and peace as you trust in him, so that you may overflow with hope by the power of the Holy Spirit" (Romans 15:13).

A key phrase in this verse is, "as you trust in him." Could the apostle Paul be telling us that trust in God leads us to hope? I think most of us would say we trust in God. I find I can say that with my mouth but sometimes there are telltale signs that perhaps it is not totally true. When worry and anxiety creep into my mind and hope begins to dim, it could be a sign my trust is not as strong as it should be.

Psalm 20:7 says, "Some trust in chariots or horses, but we trust in the name of the Lord our God." In the twenty-first century, most of us don't put our trust in chariots or horses, but many of us (myself included) may find ourselves trusting the things of this broken world rather than God. Some substitutes for placing trust in chariots and horses might be:

- Some trust in bank accounts and big houses.
- Some trust in degrees and job titles.
- Some trust in scientific knowledge and logical thinking.
- Some trust in arsenals of weapons and political powers.
- Some trust in their own expertise and strength.
- Some trust in medical knowledge and healthy living.

None of these things are inherently bad and many are good things, but are they completely trustworthy? Everything short of God is fallible and will at some point let us down or disappoint us. God doesn't want us to place our trust in things that will only disappoint and aren't worthy. And trusting someone or something rather than God, is just plain ol' idolatry. Only God is worthy of our trust and the path to hope has to be based on him alone.

When anxiety or worry creeps into my head and heart, there are three steps that will get me back on the path to hope:

1. Pause and honestly assess—where or in whom am I placing my trust?
2. Ask God's forgiveness for my wandering heart.
3. Ask the Holy Spirit to empower me to return my trust to God alone.

I'm pretty sure these steps will work for you too. I know I will have to do this "trust adjustment" frequently. My prayer for all of us is that we will do it as often as needed to get back on the path to hope!

PRAISEWORTHY

Sincere thanksgiving leads us to praise God. According to Bible Gateway, the word praise is in the Bible (NIV version) 363 times, with 182 of those in the Psalms. We know David, author of many of the Psalms, as a man after God's heart (Acts 13:22). David made a habit of praising God regardless of his circumstances. His example leads me to believe that praise is a necessary component of a healthy relationship with our God!

Sometimes my praise of God is a bit too rote or routine or a bit half-hearted or plain ol' wimpy. Praise is supposed to be about celebrating who God is. It should call us into awe, reverence, wonder, and never-ending gratitude. In order to truly praise him, I need to meditate on what his Word reveals about his character. Praise calls for an investment of my time and energy. This investment results in what I have depicted in *Praises Rising* as an ongoing stream of praise "bubbles" moving heavenward toward our Mighty God.

Praise also calls me to humble recognition of what I am not. I am not God, even though I find it very easy to pretend I am in charge of my life. Praise gives me much needed perspective.

I took the time to think about praise a bit more. None of my thoughts are terribly profound. They are familiar truths, but I occasionally need a reminder to jolt me out of what may have become rote or half-hearted. Maybe you do too! God's character has a multitude of praiseworthy aspects, so here's a few of them:

1. God is holy. Isaiah 6:3 says, "Holy, holy, holy is the Lord Almighty" He is divine, without fault. On my own merits, I am certainly not holy. It is laughable to even think of me as holy! However, through the death and resurrection of his Son, he sees me (and you) as holy and calls us into communion with him. That is worthy of praise.

2. God is love. Because of his holiness, his love is the only pure love in creation. His love is unfailing and endures forever. Romans 8:39 tells us that nothing can "separate us from the love of God that is in Christ Jesus our Lord." My love, however, is often fragile, fickle, and tainted with self-interest. God, in his mercy, has given us a helper in the Holy Spirit so we can slowly become capable of purer and purer love. His love is praiseworthy.

3. God is faithful. Psalm 36 tells us his faithfulness reaches to the skies. God makes promises and keeps them. Despite my best intentions, I can be more flaky than faithful. What a comfort to know his promise of eternal life through his Son is a sure thing and once again, is worthy of my praise.

4. God is creator. God spoke all of creation into being (Genesis 1). From nothing, he created all of the heavens and the earth. He created each one of us. Since we are all made in his image, we all have a bit of the Creator that oozes out of us in creative ways. I may be able (with his help) to take a blank canvas and create a painting using different elements of his creation, but I have no power to create something out of nothing. Our Creator is praiseworthy.

I could keep on going with many more of God's attributes, but I think you get the point! It dawns on me that God is worthy of our praise simply because he IS. In Exodus 3, Moses has a conversation with God at the burning bush. He asks God what his name is. God responds, "I am who I am." God IS and his revelation of himself to us through his Word is reason enough for all of us to spend the rest of eternity praising him.

In the approaching Advent season with all of the parties, pageants, and presents, I don't want my praise to get lost or diminished. As we celebrate the greatest demonstration of his love, the gift of his Son, I want to take the time to praise him with a fresh sense of awe, wonder, and profound gratitude. My prayer is that Psalm 146:2 becomes a reality for all of us: "I will praise the Lord all of my life; I will sing praise to my God as long as I live."

PRAISES RISING

"I will praise the Lord
all of my life;
I will sing praise to my
God as long as I live."
Psalm 146:2

ALWAYS GRATEFUL

"And whatever you do, whether in word or deed do it all in the name of the Lord Jesus, giving thanks to God the Father through him." Colossians 3:17

SIMPLY GRATEFUL

This week the Holy Spirit taught me a lesson about gratitude in the form of a simple prayer.

Our three grandsons were at our home Sunday evening for a "spend the night" party with Papi and Nonni. As we were ready to consume our delicious, roasted-over-the-fire-pit hot dogs, our youngest grandson, Lane, volunteered to say the blessing. There was nothing fancy about Lane's prayer, he just told God what he was grateful for. It was basically a list of Mommy, Daddy, his brothers (by name), and his grandparents (also by name). He repeated his list a couple of times and we all said Amen!

As I later reflected on his prayer, the Holy Spirit gently revealed to me that I didn't need to write something profound about gratitude. He showed me that gratitude is pretty simple. It is simply the answer to two questions. For whom or what are you grateful? And to whom do you give the thanks?

Let's tackle the "for whom and what" question first. The Bible speaks pretty clearly and often on this.

- "Do not be anxious about anything, but in *every* situation, by prayer and petition, with thanksgiving, present your requests to God. And the peace of God, which transcends all understanding, will guard your hearts and your minds in Christ Jesus" (Philippians 4:6-7).
- "Sing and make music from your heart to the Lord, *always* giving thanks to God the Father for *everything*, in the name of our Lord Jesus Christ" (Ephesians 5:19b-20).
- "Give thanks in *all* circumstances; for this is God's will for you in Christ Jesus" (1 Thessalonians 5:18).

I have added some emphasis to a few words in these scriptures. I think you will see a consistent answer to our question—*always* be grateful for *everything*. That is a pretty simple answer. Not always easy to do, but simple, nevertheless. There is always something to be grateful for. I have found if I dig deep enough (with the help of the Holy Spirit) into the worst of situations, I find God has always delivered a blessing of some kind.

The second question is "Who gets the thanks?" We teach our children and grandchildren to say thank you whenever they receive something. We all try to practice that ourselves—right? It's good manners! Really, it's more than that; it is training us to look beyond ourselves and to realize life itself is a gift and ultimately the giver of that gift is God. James 1:17 says, "Every good and perfect gift is from above, coming down from the Father of the heavenly lights." The beautiful thing is that when we give thanks to God, we are worshiping him. Psalm 95:2 tells us, "Let us come before him with thanksgiving and extol him with music and song." We don't have to sing our thanks to God for it to count as worship: but if the Spirit moves you, go for it!

A simple equation, yes; but the benefits we reap from this discipline of gratitude are deep and profound. Have you ever noticed when you begin to give thanks for the people, things, and situations in your life, you automatically begin to smile? In this painting, *Always Grateful*, I've tried to communicate the wonderful effervescence of joy that comes from a grateful heart.

If we look back to some of the verses above, we find the benefits of a grateful heart include the peace of God, music in your heart (sounds like joy to me!), and worship. Colossians 2:6-7 lists some additional benefits: "So then, just as you received Christ Jesus as Lord, continue to live your lives in him, rooted and built up in him, strengthened in the faith as you were taught, and overflowing with thankfulness." Not only does gratitude give us peace and joy and lead us to worship, we are spiritually strengthened when we have grateful hearts.

Gratitude is so good for us that God wants it to be a way of life for us, not a once a year event. "And *whatever* you do, whether in word or deed, do it all in the name of the Lord Jesus, giving thanks to God the Father through him" (Colossians 3:17). My Thanksgiving prayer is that in all the "whatevers" of our lives, we will always give thanks to the Giver of all good gifts.

May you have a happy and blessed Thanksgiving!

CHRISTMAS WISH OR CHRISTMAS HOPE?

This past Sunday was the first Sunday of Advent and in churches all over the world, the first candle in the Advent Wreath was lit. In the Reformed tradition, the first candle is the Hope candle. The lighting ceremony prompted me to reflect a bit on the hope the candle represents. My mind tends to wander when I spend time reflecting, and I started to think about the difference between hoping and wishing.

I went to Bible Gateway to see how often the words "hope" and "wish" are used in the Bible. Hope is used 180 times and wish forty-two times. I then checked the Merriam-Webster definitions of hope and wish. Let's compare the definition of the two words as verbs:

Wish: to have a desire; want.

Hope: to desire with expectation of obtainment or fulfillment; to expect with confidence.

I am not a biblical scholar or a theologian, but it seems to me the word hope has more spiritual significance than does the word wish. Wishing seems to be a bit more transient and fleeting, reflecting earthly wants and desires. Wishing doesn't seem to be grounded in a firm confidence in the outcome. I think the phrase "wishy-washy" just might reflect the nature of our wishes!

On the other hand, our hope is based on none other than the Creator of the heavens and earth. There is nothing "wishy-washy" about hope and for good reason. Psalm 62:5 says, "Yes, my soul, find rest in God; my hope comes from him." And Psalm 33:20 tells us, "We wait in hope for the Lord; he is our help and our shield." Our hope is firmly planted in our eternal God whose unfailing love manifested itself in the birth of our Savior over 2,000 years ago. Our knowledge of God gives us confidence that our hopes will be fulfilled.

The apostle Peter reinforces our confidence: "Praise be to the God and Father of our Lord Jesus Christ! In his great mercy he has given us new birth into a living hope through the resurrection of Jesus Christ from the dead, and into an inheritance that can never perish, spoil or fade. This inheritance is kept in heaven for you. (1 Peter 1:3-4). Just in case we haven't absorbed the message fully, Hebrews 6:19 tells us, "We have this hope as an anchor for the soul, firm and secure."

The familiar words from "O Little Town of Bethlehem," "The hopes and fears of all the years are met in thee tonight," suddenly had fresh meaning for me. All of our eternal hope is in the birth, life, death, and resurrection of Jesus. Our souls can rest on these truths. We can stand firm in the storms of life based on this anchor. Our hope is living and will last into eternity. How can we not be filled with awe, wonder, and gratitude when we think about the baby in the manger?

All of these ponderings led me to paint *Christmas Dawns*. As I painted it, I used rich and vibrant colors to reflect not only the extravagant love of God but also to convey a sense of wonder and appreciation for the hope we have—hope that arrived in a manger.

My hope is that your Christmas season is full of hope! May God bless you with a fresh sense of awe, wonder, and gratitude for his indescribable gift, Jesus Christ, the Savior of the world.

CHRISTMAS DAWNS

"The people walking in darkness have seen a great light;
on those living in the land of deep darkness a light has dawned." Isaiah 9:2

SACRIFICE

"Follow God's example, therefore, as dearly loved children and walk in the way of love, just as Christ loved us and gave himself up for us as a fragrant offering and sacrifice to God." Ephesians 5:1-2

PERFECT LOVE

It's week two of Advent, which means this past Sunday the Love candle was lit in Advent wreaths all over the world. Love is a word that gets tossed around liberally. I love guacamole and a warm shower. I love my husband. All of those loves are great, but they aren't really the love we celebrate during Advent. During Advent we reflect on the perfect and holy love of God, which is a bit different than my love of guacamole!

1 John 4:8 tells us, "God is love." Love is his essence, his motivation, and his intention for all creation. Since he is perfect, his love is perfect. During this season, we celebrate God's greatest act of love, "For God so loved the world that he gave his one and only Son, that whoever believes in him shall not perish but have eternal life" (John 3:16). Scripture gives us multiple insights into his perfect love, so I thought we'd take a peek to better understand God's perfect love. Caution! These insights aren't in his Word just to instruct us on the nature of God. They are also models for us to follow.

Genesis 22 recounts the story of God's command to Abraham to sacrifice his long-awaited son, Isaac. In this familiar story, Abraham's faith in a loving God, propelled him to obey what must have seemed like a hideous request from God; to kill his son as a sacrificial offering. When Isaac asked his father where the lamb was for their offering, Abraham told Isaac that God would provide the lamb for the sacrifice. And indeed, he did—a ram stuck in a bush.

A few thousand years later, God himself was in the position of sacrificing his only Son. His love for us was so perfect that he sent his only Son as the sacrifice for all my sins and all of yours. This time there was no last-minute ram trapped in a bush to save Jesus from death on the cross. Now, I have grandsons and I cannot even fathom the pain of sending one of them off to a certain death. Yet God loved you and me enough to do that.

These Biblical accounts show me that perfect love is sacrificial. Because he sacrificed his son, I am not required to sacrifice one of my grandsons, but I am called to sacrificial living. In Psalm 51:16-17, David prays, "You do not delight in sacrifice, or I would bring it; you do not take pleasure in burnt offerings. My sacrifice, O God, is a broken spirit; a broken and contrite heart you, God, will not despise." God wants our sacrifice in the act of surrendering our stubborn, self-focused will to him. When I sacrifice my highly imperfect desires and submit to him, I am moving a bit closer to modeling his perfect love.

When I painted *Sacrifice*, I used a variety of materials to communicate both the beautiful and harsh realities of sacrifice. For background I used a variety of papers with beautiful flowers and designs. This beauty is a weak representation of the unimaginable beauty of God's love for us. To portray the cross, I used rusting pieces of iron garden border as a reminder of the pain and suffering Christ endured for you and me. Love is the backdrop and motivation for Christ's sacrifice, and it must be the same for us.

Jesus showed us another aspect of perfect love—it is difficult and painful (for a time). He showed us how difficult love can be when he prayed in the Garden of Gethsemane (Matthew 26:36-46). Three times Jesus prayed that if possible, he would like God to take his cup (his death on the cross) away from him. With each of those requests he also submitted this desire to his Father's will. I take comfort in the knowledge that Jesus knows how hard it is for me to sacrifice my own will and desires. He can relate to my ongoing struggles to submit to God's plan for me. Unlike Jesus, I don't always submit after my third reprieve request!

He also knows I may suffer some short-term pain. Like most of us, I hate pain and try to avoid it if at all possible. This passage is a helpful reminder that any temporary pain I may suffer doesn't compare with Christ's excruciating death on the cross. He comforts me with his promise to be with me in the difficulty and pain: "And surely I am with you always, to the very end of the age" (Matthew 28:20).

Although I will never reach perfection in my love while here on earth, I do know perfect love ultimately waits for me with God—in heaven and for eternity. I am blessed! May you be blessed with a fresh sense of gratitude for his perfect love this week.

SING FOR JOY

We use the word joy frequently during the Christmas season. This past Sunday we lit the joy Advent candle. We sing "Joy to the World." I think the yearning for joy, true joy, is hardwired into our DNA. Who doesn't want to experience joy? During this season, we are often lured into thinking joy comes with more lights and decorations, parties and people, perfect presents, abundant food and drink, songs and dances, sweaters so ugly they are cute, and on and on and on. All of those things can be fun and cheerful and happy, but do they bring real joy? How do we experience real joy?

The Psalms give us some great insights into joy. Psalm 16:11 says, "You will fill me with joy in your presence, with eternal pleasures at your right hand." Psalm 86:4 tells us, "Bring joy to your servant, Lord, for I put my trust in you." It seems joy is a spiritual condition. It is more than emotion although emotion often accompanies joy. What is very clear is that God is the source of our joy. Psalm 90:14 reveals that only he can provide the deep, satisfying joy our souls long for: "Satisfy us in the morning with your unfailing love, that we may sing for joy and be glad all our days."

So is it as easy as saying, "God give me joy"? My experience has been that joy is not a quick request but is a by-product of my relationship with God. Romans 15:13 has this to say: "May the God of hope fill you with all joy and peace as you trust in him, so that you may overflow with hope by the power of the Holy Spirit." Trusting God is a key to joy.

Trust is a very loaded word. It means that I trust God wants the very best for me and his plans are better than my plans. It also means I trust him enough to surrender my wants and desires and respond in obedience to his desires for my life. Joy, the real deal, comes when we do that. When we make him our first love and our primary focus, joy is inevitable. Jesus knew that. Hebrews 12:2 describes his surrender to his Father's will: "For the joy set before him he endured the cross, scorning its shame, and sat down at the right hand of the throne of God."

I don't know about you, but my trust and focus are a bit unreliable. I think I have a bit of spiritual ADD (attention deficit disorder). This time of year, I get distracted by all the holiday happenings. I experience some happiness and fun, but it is fleeting and doesn't satisfy that longing in my soul. I get focused on me, me, me and I begin to trust in my own wisdom and strength. Then I wonder why I am not experiencing the joy for which my soul thirsts.

Here's the deal: once you have experienced the joy that comes with real trust and surrender to him, you really notice when it is lacking in your life. Christmas is the perfect time to remember God loves us and wants us to experience his joy—joy that causes our hearts to sing. Let's take the time to remember that he sent his Son to provide the opportunity for each of us to experience eternal joy with him. How can our hearts not sing for joy? Perhaps you can use this painting, *Sing*, as a reminder!

May God bless you and yours with a Christmas filled with the deep and abiding joy only he can provide.

SING

"As for me I will declare this forever;
I will sing praise to the God of Jacob." Psalm 75:9

UNSHAKEN

"'Though the mountains be
shaken and the hills
be removed,
yet my unfailing love for you
will not be shaken nor my
covenant of peace be removed,'
says the Lord, who has
compassion on you."
Isaiah 54:10

TRUST ISSUES

When the Holy Spirit gives me a topic or verse on which to build a devotional, more often than not, it contains a message that I need. Most of the time, I am writing to me. It is my prayer that God uses my weaknesses and the words which he provides to strengthen others who may be similarly afflicted!

This week I have been thinking about trusting God—down deep, unshakable trust. I am facing a big decision and I know God will provide direction to me. I say I trust him, and I have plenty of evidence to support that trust both in my own life and in the Bible. Yet moments after telling God how much I trust him, I find myself trying to put my own plans into action even though my wisdom, knowledge and strength are not adequate for the task. Sadly, I find my trust in him is a bit shallow, flimsy, and easily misplaced.

The Bible has plenty to say on this topic. In multiple ways Scripture reveals God's desire for us (and our need) to trust him completely. Psalm 62:8 says, "Trust in him at all times, you people; pour out your hearts to him, for God is our refuge." I love the wording in this admonition. The "you people" reinforces that this is an important message and we need to pay attention. Psalm 143:8 articulates the compelling message that our very lives are in his hands. "Let the morning bring me word of your unfailing love, for I have put my trust in you. Show me the way I should go, for to you I entrust my life."

I based this painting, *Unshaken*, on Isaiah 54:10, which is a beautiful reminder that God is completely worthy of my trust: "'Though the mountains be shaken and the hills be removed, yet my unfailing love for you will not be shaken nor my covenant of peace be removed,' says the Lord, who has compassion on you." Yet it often is something far less significant than a shaking mountain to cause my trust to start shaking.

When my trust for God fades quickly into doubt or even distrust, who or what am I trusting? If I am honest with myself, I fall into trusting myself. I decide to trust frail, fragile, feeble, and flaky me. My underlying problem is clinging to the delusion that my plans are just as good as his plans. Scripture has plenty to say about the folly of this approach.

"Blessed is the one who trusts in the Lord, who does not look to the proud, to those who turn aside to false gods" (Psalm 40:4). Ouch! How often do I look to a false god (my prideful self) instead of trusting the one true God for direction?

Proverbs 28:26 minces no words on the subject, "Those who trust in themselves are fools, but those who walk in wisdom are kept safe." Strong words, yet my stubborn self continues to wander into foolishness.

The Bible reassures us that our trust in the God of all creation is far from folly. God's only motive for his plans is his perfect, unfailing love for us. He wants us to live fully and thrive as we submit to his plans for our lives. Sometimes I think God is speaking directly to me when I read Isaiah 30:15, "This is what the Sovereign Lord, the Holy One of Israel, says: 'In repentance and rest is your salvation, in quietness and trust is your strength, but you would have none of it.'" God's richest blessings await when we trust in him. Jeremiah 17:7 reassures us, "But blessed is the one who trusts in the Lord, whose confidence is in him."

My prayer is that you and I will live in the promises of Romans 15:13: "May the God of hope fill you with all joy and peace as you trust in him, so that you may overflow with hope by the power of the Holy Spirit." The blessings of joy, peace, and hope all flow from a deep and abiding trust in God. The power of the Holy Spirit makes it possible for each of us. Amen!

CLOSING THOUGHTS

When God called me to paint and write devotionals, I was sure about the calling, but I was unsure of why. Why did he want me to devote my time to this? What purpose did he have for these devotionals and paintings? I really had no clue for quite some time, but I knew he had a purpose even if I didn't know what it was.

One lesson I have learned along the way is that we are to obey him even if we don't understand the whys. So for about a year and a half I just kept painting and writing.

It wasn't until the fall of 2019 that I began to sense God's purpose in this calling. I was studying 1 & 2 Thessalonians and the apostle Paul's frequent use of the word encourage began to bounce around in my head.

- "Therefore encourage one another with these words" (I Thessalonians 4:18).
- "Therefore encourage one another and build each other up, just as in fact you are doing" (1 Thessalonians 5:11).
- "And we urge you, brothers and sisters, . . . encourage the disheartened, help the weak, be patient with everyone" (1 Thessalonians 5:14).

It was then that I realized God's purpose was for me to encourage others in their Christian walk. Although unqualified and ill-equipped (look back at the Introduction for a refresher!), I am called to encourage. It is my prayer that God will use this book to give you his *Words of Encouragement,* which happens to be the title of this painting! May God's encouraging words soak into your soul and bless you on your journey to becoming his masterpiece.

WORDS OF ENCOURAGEMENT

"Therefore encourage one another and build each other up, just as in fact you are doing."
1 Thessalonians 5:11

ENDNOTES

i BibleGateway search of NIV for the word "wait," www.biblegateway.com (Grand Rapids: Zondervan), source verified on October 16, 2019.

ii Greg Ogen, *Essential Guide to Becoming a Disciple: Eight Sessions for Mentoring and Discipleship* (Downers Grove, IL: Intervarsity Press, 2016), 50-57.

iii Dr. Tony Evan speaking on a "Two Minutes with Tony" segment on KSBJ 89.3 radio, Houston, TX. Exact air date is unknown. Approximate date is August/September, 2018.

iv Sarah Young, *Jesus Always: Embracing Joy in His Presence* (Nashville: Thomas Nelson, 2016), 272.

v Dictionary.com search for word "faithful," www.dictionary.com (Oakland: Ask, an IAC company), source accessed October 11, 2019.

vi Dr. Suess, *Horton Hatches the Egg* (New York: Random House, 1940), 16, 21, 26, 38.

vii Dictionary.com search for definition of word "perseverance," www.dictionary.com (Oakland: Ask, an IAC company), source accessed October 11, 2019.

viii BibleGateway search of NIV for the word "praise," www.biblegateway.com (Grand Rapids: Zondervan), source verified on October 11, 2019.

ix BibleGateway search of NIV for the words "wish" and "hope," www.biblegateway.com (Grand Rapids: Zondervan), source verified on October 11, 2019.

x Merriam-Webster.com search for definition of "hope" and "wish," www.merriam-webster.com (Springfield, MA: Merriam-Webster, Incorporated, 2019), source verified on October 11, 2019.